A Survival Guide
for
Art History Students

A Survival Guide for Art History Students

Christina Maranci

University of Wisconsin-Milwaukee

Upper Saddle River, New Jersey 07458

Library of Congress Cataloging-in-Publication Data

Maranci, Christina (date)
 A survival guide for art history students / Christina Maranci.
 p. cm.
 Includes index.
 ISBN 0-13-140197-1
 1. Art—History—Study and teaching (Higher)—United States. 2. Study skills—United
States—Handbooks, manuals, etc. I. Title.

N385.M37 2005
707'.1'1—dc22 2004044626

Acquisitions Editor: Sarah Touborg
Editor-in-Chief: Sarah Touborg
Editorial Assistant: Sasha Anderson
Marketing Manager: Sheryl Adams
Marketing Assistant: Kimberly Daum
Production Editor: Jean Lapidus
Prepress & Manufacturing Buyer: Sherry Lewis
Copy Editor: Stephen C. Hopkins
Indexer: Murray Fisher
Image Permission Coordinator: Craig A. Jones
Cover Design: Bruce Kenselaar
Cover Art: Nike of Samothrace (Winged Victory)
 Source: Musee Du Louvre. Paris/SuperStock
Composition: Interactive Composition Corporation (ICC)
Cover Printer: Phoenix Color/Hagerstown

Pearson Education LTD. Pearson Education Australia PTY, Limited
Pearson Education Singapore, Pte. Ltd Pearson Education North Asia Ltd
Pearson Education, Canada, Ltd Pearson Educación de Mexico, S.A. de C.V.
Pearson Education–Japan Pearson Education Malaysia, Pte. Ltd

10 9
ISBN 0-13-140197-1

Contents

Preface *ix*

Acknowledgments *xi*

1 WHY TAKE AN ART HISTORY CLASS? 1

The Value of Visual Literacy *1*

Art History Myths Debunked *3*

2 THE ART HISTORY CLASSROOM:
An Initiation 5

The Anatomy of an Art History Class *6*

 Recognizing Kinds of Visual Information *7*

 Organizing Information from the Lecture *9*

 The Content of an Image *16*

The Visual Description of an Image *18*

The Formal Analysis of an Image *20*

The Macrostatement and the Comparison *21*

Taking Notes in Art History *23*

Organizing the Page *25*

Note-Taking on Comparisons *28*

3 PUTTING WORDS TO IMAGES:
Mastering the Response Essay **33**

Working in the "White Box": The Museum
and Gallery Experience *35*

Selecting a Work of Art *36*

Recording Your Impressions *37*

Formal Elements *41*

Writing the Paper *64*

The Introduction *65*

Writing the Main Body *66*

Some Further Tips on Writing *69*

4 THE ART HISTORY EXAM **71**

The Basic Parts of an Art History Exam *72*

Identifications *73*

Exam Time *78*

Short-Answer Identifications *78*

Slide Comparisons *80*

The Essay Question *89*

The Unknown *94*

5 RESEARCH PROJECTS IN ART HISTORY **97**

Formulating a Topic *98*

Finding Bibliographic Materials *98*
Finding Images on the Internet *99*
Finding Scholarly Work on the Internet *100*
The Library Visit *110*

Seven Tips for Writing the Research Paper *115*
Formatting Your Citations *117*
Analyzing Scholarship *120*

6 WHAT DO YOU DO WITH A DEGREE
IN ART HISTORY? **126**

Museum Work *127*

The Commercial Art World *131*
The Art Gallery *131*
The Antique Market *132*
The Auction House *133*
The Corporate Curator, Curatorial Consultant,
and Arts Organization Consultant *134*

The Publishing World *136*
Alternative Careers in Writing *137*

The Arts Agency *138*

 Working at the National Level 138

 Working at the State and Local Level 139

And If You Decide to Get an Advanced Degree . . . *140*

 A Final Word of Encouragement 145

GLOSSARY 146

INDEX 151

Preface

TO THE STUDENT

This book is written for you, the college student, who has had little or no experience with courses in art history. While you are familiar with how English classes are run, and feel comfortable with the format of science labs, what you will experience in an art history class is entirely new. As the class begins, the lights go down, and slides are projected on screens in pairs. Certainly, you have been to slide lectures before, but in those cases only one slide was projected at a time. And not only is the visual format new, but now your professor is actually *talking about the slides*. You had always thought that art was meant to be admired in silence. How are you, a student, supposed to put your own words to great works of art? In the upcoming weeks, you will be asked to do just that—to speak about images, to write about them, to remember them, to prioritize information about them—in sum, to engage with them visually in a way that has never been asked from you before. This book is designed to guide you through the process, assisting you with art history papers, exams, and note-taking. It will also help you with two frequently asked questions: "Why take an art history course?" and "What in the world do I do with a major in art

history?" Finally, knowing that you are already saddled with tedious reading assignments, I have written the book in a style that is conversational and humorous.

TO THE TEACHER

As teachers, we often forget the profound disorientation that first-time art history students can experience. Yet as I have learned from numerous conversations with my students, the transition from other courses to art history is not a natural one. It often takes weeks for students to become acclimatized; some, particularly in large lecture classes, never do. "This is my first art history class," I am told after lecture. "I don't know what I am doing." Those who *have* previously taken a course or two are regarded with awe, as though they are members of some secret society.

This book will accompany the student through the adjustment process. It is intended to be read either straight through, in tandem with, or prior to your lectures, or as a reference text. Its organization reflects what I believe are the standard components of the introductory art history class as taught in colleges and universities in the United States. Hence it focuses on the traditional canon. I admit that African, pre-Columbian, and Native American art are not covered here, nor are newer forms of art, such as video and film.

Each chapter will address a different aspect of the course. Chapter One emphasizes the value of art history as a discipline. Chapter Two is devoted to note-taking and listening in lectures. Chapter Three covers the process of writing response essays. In Chapter Four we deal with taking art history exams, and Chapter Five explores research projects. Although many existing guidebooks define basic terms and concepts used in the discipline, this book also explains *how* to take art history: how to listen to a lecture, how to discuss images, and how to study. Chapters will include strong (and weak) examples of exam answers and paper extracts. They will also address some of the usual worries of art history students: "How can I possibly write a five-page paper describing one work of art?" The concluding chapter focuses on career options in the field.

Acknowledgments

I would like to thank editors Bud Therien and Sarah Touborg for their encouragement and guidance, and also Sasha Anderson, who remained patient and cheerful in spite of numerous delays and excuses. Several others must also be acknowledged: Janet Temos, who believed in the book from the very start, my colleagues at the University of Wisconsin-Milwaukee, my graduate student Valerie Rudy, who provided many helpful insights and suggestions, and the prepublication reviewers of the manuscript, who are as follows: Patricia Coronel of Colorado State University; Virginia M. da Costa of West Chester University; Martha Holmes of Fort Hays State University; Carol Solomon Kiefer of Amherst College; Miles David Samson of Worcester Polytechnic Institute; and Harry Titus, Jr. of Wake Forest University. The greatest thanks, of course, go to my students. Their need for guidance amidst the profoundly disorienting experience of art history class inspired the words that follow. This book is dedicated to Brian, who saw it from beginning to end with unfailing patience, support, good humor, and glasses of Chardonnay.

Christina Maranci
Milwaukee, Wisconsin

A Survival Guide
for
Art History Students

1
Why Take an Art History Class?

In the old days, people took art history to learn about the paintings they inherited from Granddaddy. Now, there are other reasons. Think about it: we live in a visual world, bombarded by images from television, magazines, and the internet. Therefore, those who have the power to talk about images, who are comfortable interpreting images, and who have a sense of the history, power, and function of images hold a considerable advantage in modern society. A knowledge of art history can provide you with that advantage, while, at the same time, providing you with a sense of the development of cultures over time.

THE VALUE OF VISUAL LITERACY

You are on campus, sitting in the student union, and chatting with your friends about the courses you are planning to take. Many of them have already signed up for biology (a requirement for pre-med students), economics (important for the business world), and English (useful for aspiring writers and law students). "What about art history?" someone suggests, flipping through the course catalogue. You hesitate. Why should you take an *art history* course? Who actually needs to learn to appreciate

art—don't you already know what you like? And how exactly could you *use* an art history class in the "real world"?

As a professor of art history, I am going to give you the reasons why you should take courses in this field. I am admittedly biased. However, I also have privileged knowledge about what the discipline can do for you. Art history can provide you with skills and learning not available through the study of other disciplines. Moreover, the skills and knowledge acquired through such study will be of great value to you in whatever career path you choose. You will find that taking art history means more than just learning a new set of facts and ideas. It also means gaining a new kind of literacy—**visual literacy.** (Note that all terms in **boldface** are also located in the Glossary.)

What do I mean by this? *Visual literacy* means the ability to "read" the world of appearances; to understand what gives them power. This kind of literacy is important to understanding phenomena such as body language, a city plan, or a provocative poster. And it is particularly critical for life in a world that revolves around images. In the "real world" images are inescapable: pick up a magazine, turn on your television or your computer, and you are in immediate contact with a series of visual images and the messages they impact. These messages are often carefully crafted. For example, graphic designers make choices about the form, composition, and color of advertisements to persuade the consumer to buy certain products. Often such manipulations are quite subtle. Photographs of female models can no longer be understood as depicting the bodies of real women—rather these images are often digitally enhanced to conform to a cultural ideal in an effort to sell goods. Despite the power of such images, and their omnipresence in modern society, we often glance over them quite passively, barely aware of the responses they elicit from us. Art history teaches you to become sensitive to their potency, and it can transform you from a passive viewer to an active viewer.

There are other advantages to taking art history. As with written texts, works of art also communicate the history of a civilization. And if you are not a particularly good student of history, you may find learning history through images much easier and more enjoyable. (My high school classes on the French Revolution are a complete blur to me now, except for the magnificent portrait of Napoleon on his white horse.) For many of us, the study of history comes alive through images. Moreover, by its very nature, the study of art also intersects with numerous other disciplines, including philosophy, religion, literature, and even the sciences. For example, in the ancient Near East, art was often the means to express political

power and religious devotion. So art history is more than simply *art* and *history*—it is a multidisciplinary field, allowing you access to many different kinds of learning.

For studio artists, knowledge of art history is also critical. Not only will you learn the language and history of art, but you will come into contact with an array of artistic techniques and materials that will enrich your own creative experience. The course will also give you a sense of your own place in the history of art by showing you the artistic movements that preceded your own efforts.

Finally, knowledge of art history can completely transform a trip abroad. Many of my students approach me after traveling to Europe or elsewhere and after visiting an art museum or architectural site that we have studied in class. They excitedly recount their experience of seeing it "in the flesh." You too will discover that travel can be a wonderful moment of artistic discovery, and all the advance knowledge that you have gained in class will intensify your firsthand encounter with great works of art. Wouldn't you like to exit a museum with something more than aching feet and the fatigue of incomprehension? If so, read on.

ART HISTORY MYTHS DEBUNKED

Myth 1: Art History Is a Gut Course. First, allow me to debunk some common assumptions about art history courses. The first and most common misconception is that such courses require no effort. Each year in my survey course, a group of students become dismayed when they find out that they will actually have to study for exams. They were under the impression that art history is simply about looking at pictures and talking about the way you feel. In a way, this is true—you *will* be looking at images and you *will* be asked to provide your perception of them. But try looking at an image right now. What can you say about it? It is quite possible you might only come up with a sentence or two—"This is a scene of a train station" or "This is a woman in a convertible" or "This is ugly." What more is there to say, you ask? A lot more. Putting words to images requires the visual literacy we spoke of earlier, a necessary tool in learning to "decode" works of art. In art history classes, you will learn to *really look* at an image and speak about it using language that is precise and powerful. This will require effort on your part. Having said that, however, let me add that you should not feel at all intimidated—art history generally requires no more or less work than any other course in the humanities. But such a course is not a "gut."

Myth 2: In Art History Class, Black Turtlenecks Are the Uniform. The second assumption is that art history is for pretentious people. We all know the stereotype of the art historian or critic who wears all black and sits in a café and smokes, speaking in a hybrid of French, German, and English. While we are at it, here are a few more stereotypes associated with the art world: the snooty gallery owner, the British antiques connoisseur (as seen on the *Antiques Roadshow*), and the female art lecturer with the huge shawl, long earrings, and flutey voice. In a sense, all of these stereotypes actually exist in the real world—one can certainly identify people who fit such descriptions. But it is important that you separate your assessment of such a personality from your judgment of the discipline. For example, I am sure you are well aware that the study of physics is not just for men with pocket protectors, huge eyeglasses, and severely hemmed pants. Likewise, art history is not just for those who wear black turtlenecks. In fact, I have found that students from all backgrounds enjoy it and gain from it, including varsity football players, engineering majors, and ROTC students.

Myth 3: If You Major in Art History, Get Used to Making Lattes for the Rest of Your Life. A third assumption is about the impracticality of choosing art history as a major. What could you possibly do with an undergraduate degree in it? Perhaps make latte at the local Starbucks? There are, in fact, as many career options open to the art history major as there are for any other major in the humanities, and you can read about them in Chapter Six. If you are an aspiring lawyer, art history is just as appropriate a degree as English, sociology, or political science, providing you with experience in critical thinking and precise writing. An art history degree is an equally good foundation for careers in the commercial sector, such as careers in art galleries, with auction houses, or with art publishers. If you choose to enter into museum work, your path might take you in many different directions, from administration, fundraising, and public relations to work as a curator, dealing directly with the collection. The options are diverse and numerous. Moreover, a career in art allows you to work with creative people and interesting objects, which is more than one can say for many professions.

Disabused of the usual misconceptions surrounding the field, I hope you have chosen to sign up for an art history course. The following chapters are designed to guide you through the experience; each addresses a different task or assignment you will face in the class. A final chapter discusses career opportunities for art history majors.

2

The Art History Classroom

An Initiation

How is an art history lecture conducted? What are you supposed to take away from it? How do you take notes on a class that is primarily visual? And how are you supposed to take notes and look at images at the same time? This chapter will take you through the process.

You might be wondering why I have written a chapter on *introducing* you to an art history class. After all, you have been in school for much of your life and sat in hundreds of classrooms. You know that English, history, and math courses tend to be run the same way whether at the high school or college level. Why is it necessary to learn *how* to make sense of an art history class? I can offer you one very good reason: art history is different. In class, you will be presented with visual and verbal information in a way that departs from the standard classroom experience. And since art history is rarely included in high school curricula, an introductory college course is most likely your first exposure to it. Its foreignness has, at first, worried many of my students. After the first or second lecture, they confess to me that they don't know what to take away from the lecture, or what they should be writing in their notebooks. This chapter addresses such concerns, guiding you through an art history

lecture. It will show you how to record, prioritize, and organize the information presented, focusing on the process of note-taking. When it comes time to review for the exam, these notes will constitute an invaluable study guide.

THE ANATOMY OF AN ART HISTORY CLASS

Let's start with the basics: the anatomy of the art history class. With a few exceptions, classes are set up the same way: students sit facing the professor and a pair of screens on which images are projected. At first you will find this awkward: after all, what are you supposed to be paying attention to, the lecturer or the slides? Be patient—after a few minutes, you will find yourself shifting your gaze naturally, following the cues of the professor.

As you will be both looking and listening throughout the class, finding a good seat is crucial. Don't sit so close that you are craning your neck to view the images properly, but don't sit so far away that you cannot adequately make out all the details of the slides. From experience, I have found that the details I want students to see are often not visible from the back rows. Moreover, the noise of projectors (either for slides or digital images) can sometimes be so loud that those sitting in the rear of the classroom cannot hear every word. My advice is to sit "sixth row center," that is, in the middle and slightly toward the front, or as near to it as possible.

Perhaps the most important and novel element of encountering an art history class for the first time is the projection of images in pairs, rather than singly, for few conventional lecturers use this method when using audio-visual equipment. However, this method has characterized the American art history class since the nineteenth century. Your professor will use it to compare and contrast, pointing out artistic developments or correlations between the two images. In the lecture or in the discussion section, you will be asked to compare the two images yourself, commenting on the ways in which they are similar or different. But we are getting ahead of ourselves.

The number of images shown, and the way in which they are used, varies from professor to professor. Some maintain the philosophy that more is more: one art historian I know routinely shows fifty slide pairs in an hour class. Others use far fewer but consider each image in greater detail. The average is probably somewhere around three minutes per slide pair, with some images taking up more discussion than others. Whatever your professor's preference, it is important to understand what he or she is trying to do when showing you the slides, and what you are supposed to get out of them.

Recognizing Kinds of Visual Information

Let's take a moment here to discuss the body of images that will be shown to you. You might wonder why this requires explanation: you are going to be looking at works of art, of course! But in reality, you will probably be encountering a series of different kinds of images. Your professor might show you a slide of Claude Monet's *Water Lilies, Giverny* (1907) (fig. 1), a French Impressionist painting. He might also show you a *detail* of the painting. With sculpture, the number of possible views multiplies. Let's say your professor is discussing the *Doryphoros,* a work of ancient Greek sculpture (fig. 2). You could be presented with a full view from the front, views from the side or back, or again, a specific detail. The view chosen will depend on the point your professor is trying to make.

Architecture presents the greatest variety of possible representations. For example, you might be most familiar with the exterior view of a building. But your professor will also show you a slide of the interior as well, to give you a sense of spatial organization and the treatment of the interior wall surface. In addition, you could be shown a **ground plan.** In this case, it is as though the building has been sliced away at its base, and you are looking at it directly from above. Now you can see the entire layout of

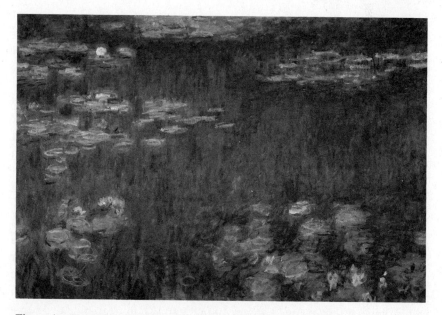

Figure 1 Claude Monet (1840–1926) French, *Water Lilies, Giverny,* 1907.
Les Numpheas. Reflets Verts. Partie Gauche. Water-Lillies. Green Reflections.
Source: Musem De L'Orangerie, Paris, France/Lauros-Giraudon, Paris. © Superstock.

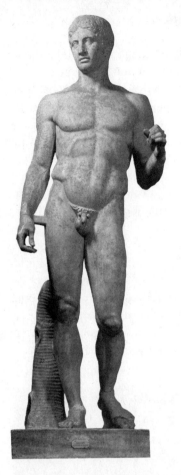

Figure 2 Polykleitos of Argos (5th B.C.E.), *Doryphoros* (Spear Bearer). Roman copy of Greek original bronze. (c. 450–440 B.C.E.) *Source:* Museo Archelogico Nazionale, Naples, Italy. Scala/Art Resource, NY.

the interior. If we slice the structure vertically, rather than horizontally at the base, we get a **cross-section,** which allows us to see other elements of the building, such as the thickness and heights of walls and the profiles of the roof. (Other representations, such as **cutaway drawings,** combine views of both the interior and exterior.)

In some cases, however the building no longer survives in its original state. For example, at the Abbey of St.-Denis in Paris, thought to be the first Gothic structure, the west front has been rebuilt. In this case, your professor will probably show you an older drawing of the building, composed when its original appearance was still preserved. Ancient monuments have often changed more dramatically. For example, the Nana Ziggurat, a temple from Mesopotamia dating between 2100–2050 B.C. is now in total ruins. However, through careful study of archaeological

remains and the study of ancient texts, scholars have been able to compose a hypothetical reconstruction of its original appearance. In addition to a view of the ruins, then, you might be shown a scholarly rendering of the structure as it originally appeared.

At this point, you might be feeling a little overwhelmed: what a lot of information, and I haven't even told you about the lecture yet! Don't worry. As the course proceeds, you will assimilate this information with increasing rapidity. For now, just be aware that works of art can be represented in a variety of ways, and that it is important for you to note these different kinds of representations. You will use this knowledge to keep a record of the slides projected by your professor, thus creating complete visual documentation of the lecture, and, by extension, the perfect study guide.

Organizing Information from the Lecture

So far, we have discussed the layout of the classroom and introduced the ways in which visual information will be presented. Now let's consider the content of the art history lecture itself. Allowing for a range of personal styles, the lecture you hear will most certainly include two components: one historical and the other visual. The following section will acquaint you with each.

Historical Background and Contextual Information. Let's first discuss the "history" in art history. This is certainly the more familiar of the two components to be discussed, as most of you have already taken a history class. Unlike such classes, however, your art history professor is going to use historical information *to elucidate works of art.* In history courses, it is often the other way around: if images are shown, they are often shown to illustrate a historical event or period. In this way, art is used as "wallpaper" for the history lecture. Your art history professor will construct the art–history relationship in a different way: she will show how historical circumstances—that is, the historical **context**—can shape a work of art and often help to explain changes in works of different periods. This historical information might be presented to you at the beginning, middle, or end of class, or might be discussed throughout.

I have been asked by many students whether this historical information is necessary to write down. My answer is *yes, by all means.* Here's an example of why: let's say you are listening to a lecture on the art of ancient Egypt. Professor P. is discussing the political history of the Upper

and Lower Kingdoms during the predynastic era. This is an *art* history class, you think, and therefore take the opportunity to slip into a happy daydream, your pen lying slack in your hand. As you look back over your notes, you will see that you have only written down information relating to the work of art introduced *after* the historical component of the lecture. You have written down the name of the work: *The Palette of Narmer* (fig. 3). You have also noted that it depicts the famous king Narmer, and that he appears on the front and back wearing two different hats thought to be symbolic of the Upper and Lower Kingdoms of Egypt. But what does all this mean? If you had been paying attention to the work's historical context, you would know that Narmer is thought to have unified the two kingdoms, and that the stone **palette** commemorates this important triumph. Such a work of official art was produced in order to communicate

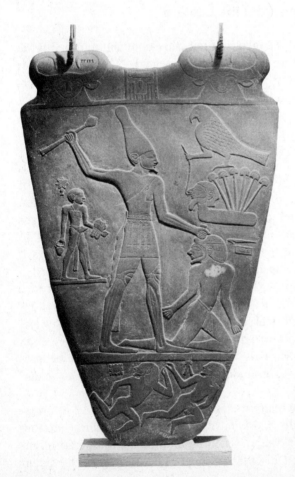

Figure 3 *Palette of Narmer,* from Hierakonpolis, Dynasty 1, c. 3150–3125 B.C. *Source:* Egyptian Museum, Cairo, Egypt. Giraudon/Art Resource, NY.

specific political messages, and so it is crucial that you understand and take note of those messages.

Let's take another example: Edgar Degas' *Day at the Races.* This image depicts a series of horses and jockeys preparing for a race in a stretch of green parkland. At the perimeter of the image are well-dressed men and ladies who have gathered to watch. You might understand the subject matter, and appreciate that it is a pretty scene, but there is much greater meaning here. The image was produced during the age of industrialization, in the nineteenth century, when the rise of tourism and rail travel allowed Europeans to seek out the pleasures of the country and engage in new leisure activities such as watching horse races. The full meaning of the work, in this case, can only be derived from an understanding of the historical context in which it was made.

Let's take one more example. Pretend you are listening to a lecture on the art of Charlemagne, the early medieval Frankish king, and your professor first provides you with an introduction to the history of the era. This is what your notebook might look like:

A. Charlemagne crowned emperor in 800 by Pope Leo in Rome

B. great political leader

 1. subdued barbarian invasions
 2. created Holy Roman Empire

C. great administrator

 1. codified and organized empire
 2. reintroduced Roman law
 3. instituted religious reform in accordance with Roman rites.

You might be asking yourself, do I really need to take all this down? Again, the answer is *yes.* When your professor turns to the art of the era of Charlemagne, you will see that this historical information is directly relevant, shaping the kinds of artistic media, subject matter, and styles of the age. Not only was Charlemagne interested in reviving Roman ideas through religious and legislative reforms, but we also witness the same desire in his artistic commissions. For example, the famous **Reliquary** *of Einhard,* named after Charlemagne's biographer, is a miniature replica of an ancient Roman **triumphal arch.**

Now, imagine that your professor asked you to compare the *Reliquary of Einhard* with a real Roman triumphal arch. It would be

important not only to talk about how the reliquary recalls the Roman form, but also how Charlemagne's Roman revival in the arts formed part of his larger political program. Speaking as a professor, there is nothing more impressive than a student who can comment intelligently on both the visual properties of a work of art *and* its historical setting. Quite simply, it demonstrates that you have been listening.

The Visual Information. While the historical component of the lecture is important, your professor will probably spend more time on the description and analysis of the images shown. As mentioned above, the way your professor engages with images might seem strange at first. I'll never forget my own first experience in an art history class as an undergraduate. I remember being shocked that the professor actually turned away from us and toward the slides, which he began to describe in detail! In a lecture, your art history professor will do the same, engaging with the works, describing their visual properties, exploring the messages they send, and comparing them with others. This is the point of art history, and in exams, papers, and discussions, it will be your turn to do the same. From my experience, this new and more active way of engaging with works of art is one of the great challenges for college students. For this reason, the following section will introduce you to the different ways in which your professor may discuss a work of art.

The "Vital Statistics" of an Image. Let's start with the basics, taking the example of an eighteenth-century French painting, Jean-Louis David's *Oath of the Horatii* (fig. 4). To introduce you to the work, your professor will most likely begin by telling you its name, when it was produced, who produced it, and where it is located. I refer to this most basic information as **vital statistics,** and it is indeed vital that you record this information in your notebook.

 This seems fairly straightforward, but note that the amount and kinds of information you write down will shift from work to work. For example, while we know the artist of the *Oath of the Horatii,* for much of ancient and medieval art the makers are unknown to us, as artists of those eras rarely signed their works. Moreover, in the case of sculpture and architecture, vital statistics will also include the materials from which the work is made. Finally, the date of a work, always included in the vital statistics, can be expressed in various and sometimes confusing ways. While you may be perfectly comfortable with a date of 1294 or 1923, often the terms used for dating (or **chronology**) are less clear to the uninitiated. If you have often secretly wondered whether 700 B.C. is earlier or more

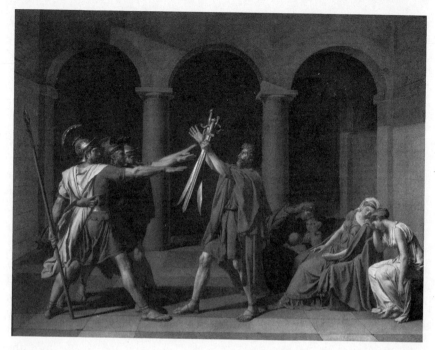

Figure 4 Jean-Louis David (1748–1825), *Oath of the Horatii*, 1784–1785 c. 1784. Oil on canvas, 330 × 425 cm. Inv.: 3692 © Reunion des Musées *Source:* Nationaux/Art Resource, NY/Louvre Museum, Paris, France. Photo: G. Blot/C.Jean.

recent than 300 A.D., or why the 1800s are referred to as the nineteenth century, see the following section, "A Quick and Easy Guide to Chronology," for guidance.

A Quick and Easy Guide to Chronology

TERMS

Decade: 10 Years
Century: 100 Years
Millennium: 1,000 Years
B.C.: (Before Christ). The era before the year 1 A.D.
A.D.: (*Anno Domini,* meaning the "year of our Lord"). The era
 beginning at the year 1 A.D. Some professors now prefer to use
 the term B.C.E. (Before the Common Era) for B.C. and C.E.
 (Common Era) for A.D.

First Rule of Thumb: With Years in the A.D. *Era, the* **Larger** *the* **Number,** *the* **More** **Recent** *the Time.* So, 1900 A.D. is more recent than 500 A.D.

EARLIER TO MORE RECENT IN A.D. YEARS

1–99 A.D.

500–599 A.D.

1900–1999 A.D.

Second Rule of Thumb: In B.C. *Years, the Opposite Is True. The* **Larger** *the* **Number,** *the* **Earlier** *the Time.* So, 500 B.C. is more recent than the 800 B.C., which is more recent than the 1300 B.C. Example: the prehistoric *Woman from Willendorf* (fig. 16) is generally dated to around 22000 B.C., but the *Nike of Samothrace* (fig. 8), a Hellenistic Greek sculpture, is dated to c. 190 B.C. The *Nike* is much, much more recent. (Note: The lowercase letter *c.* or *ca.* is an abbreviation for the Latin word *circa,* which means "around.")

EARLIER TO MORE RECENT IN B.C. YEARS

1599–1500 B.C.

1199–1100 B.C.

599–500 B.C.

99–1 B.C.

Third Rule of Thumb: The Year 1923 Is Not in the Nineteenth Century, It's in the Twentieth. Many students have trouble converting the date in centuries to the date in years, and vice versa. I find the easiest way to learn this is with the following rule: if you are given a date by century, such as the fifth century A.D., remember that to find the date in years, you should subtract *one* from *five.* Hence a date in the fifth century A.D. will be in the 400s. This rule works for *both* centuries in B.C. and A.D. So, a work dated to the third century B.C. could date anywhere from 200–299 B.C. What about 55 B.C. or 78 A.D.? Remember that years in double digits are the *first centuries* B.C. *or* A.D. So, 55 B.C. belongs to the first century B.C., and 99 A.D. is in the first century A.D. The following year, 100 A.D., is the first year of the second century A.D.

The earlier to more recent rule works with B.C. centuries as well: the smaller the number, the more recent the time. Hence, the eighteenth century B.C. (the 1700s B.C.) is *much* earlier than the eighth century B.C. (the 700s B.C.).

Centuries B.C. to A.D. (Earlier to More Recent)

Sixteenth century B.C.

Twelfth century B.C.

Sixth century B.C.

First century B.C.

First century A.D.

Sixth century A.D.

Twelfth century A.D.

Nineteenth century A.D.

Twenty-first century A.D.

This subtraction principle also works with millennia (the plural of millennium) as well.

Millennia, Earlier to More Recent

Third millennium B.C. = 2999–2000 B.C.

Second millennium B.C. = 1999–1000 B.C.

First millennium B.C. = 999–1 B.C.

First millennium A.D. = 1–999 A.D.

Second millennium A.D. = 1000–1999 A.D.

Third millennium A.D. = 2000–2999 A.D.

Other Hints

1. There is no year zero.
2. Note that *c.* or *ca.* is an abbreviation for *circa,* Latin word meaning "around" or "approximately." It is used when giving an approximate date or when the exact date is not known.
3. Professors will often use terms like "the first half of the second century A.D." or "the middle of the seventh century." Here are some examples and their equivalents in years:

 First half of second century A.D. = 100–150 A.D.

 The second quarter of the nineteenth century = 1825–1850.

 The middle of the seventh century B.C. = 650 B.C.

4. If you are given a date with no B.C. or A.D. attached, generally it can be assumed that it is in A.D. (Just as we tend to say 2004, rather than 2004 A.D.)

5. On the term *contemporary:* While this term is commonly understood to mean "modern," your professor may use contemporary to mean "equivalent in date with." Hence, you might be asked to look at a painting by Renoir and read a "contemporary text." This means a text written in the last part of the nineteenth century, at the time when Renoir was active.

What about the location of a work of art? I am often asked whether it is necessary to record it as a vital statistic. The answer varies from professor to professor, but a few generalizations can be drawn. If an object is held in a museum, and therefore divorced from its original context, you will not generally be tested on its location. (Although if you have time, I recommend you note down the museum—you never know when you might be in its vicinity, and there is nothing more pleasant than seeing firsthand a work of art that you have known only from slides.) For architecture, knowing location is imperative. You should know that the Nana Ziggurat is located in the ancient city of Ur in Mesopotamia, or that Frank Lloyd Wright's *Robie House* is in Hyde Park, Illinois. The same is generally true for works of sculpture and painting that still stand in their original venue, such as Bernini's *Ecstasy of St. Theresa,* a Baroque work that was designed for its architectural setting, the Coronaro Chapel of the church of Santa Maria della Vittoria in Rome. If in any doubt, however, you should always consult your professor.

The Content of an Image

But there is much more to an image than its vital statistics. Your professor will then begin to describe the image and explain its content. What do we mean by **content**? There are a number of opinions on the subject, but for our purposes, it is best to think of content as opposed to **form**: that is, while we may describe the form of an ancient Greek statue such as the *Doryphoros* (fig. 2) as a *composition of balanced shapes* (we'll get to that in a moment), we may describe its content as a *Greek male athlete.* Depending on the work of art, content can include several levels and types of meaning. Consider the *Augustus of Primaporta,* a Roman sculpture depicting the emperor Augustus (fig. 5). He is wearing decorated leather armor but stands barefoot, accompanied by a winged cupid riding a dolphin. In this case, your professor will not only describe to you the literal content of the image, but also the metaphorical content: the cupid and dolphin are not merely there to entertain us; rather, they are symbols

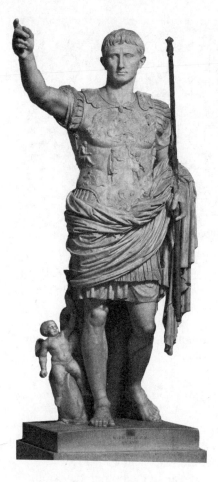

Figure 5 *Augustus of Primaporta,* early 1st century A.D. or copy of a bronze statue of c. 20 B.C. *Source:* Vatican Museums & Galleries, Rome/Canali PhotoBank, Milan/SuperStock.

associated with the family of Julius Caesar. By depicting himself with these creatures, Augustus was asserting his own lineage within that family.

If we jump to fifteenth-century Belgium, we find that content is handled in a different way. In the *Merode Altarpiece* (fig. 6), a fifteenth-century Flemish painting by Robert Campin, the right-hand panel features an aging carpenter drilling a wooden panel, the tools of his trade strewn on the desk before him and by his feet. The back wall of his small workshop is pierced by a window looking out onto a busy town. What is the content of this image? Your professor would not be doing her job if she told you that this was simply an old woodworker in a cluttered room—the person you see, in fact, is Joseph, husband of the Virgin Mary. His inclusion is an appropriate complement to the central panel of the altarpiece, which depicts the Virgin Mary greeted by the archangel Gabriel, who has come to tell her she will bear the Christ Child. In each of these cases, the

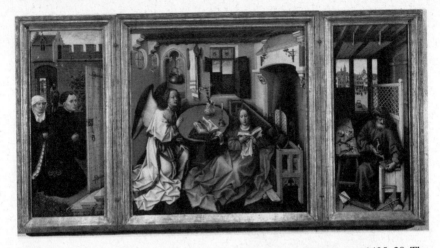

Figure 6 Robert Campin (active by 1406- d. 1444), *Merode Altarpiece,* c. 1425–28. The Annunciation (Triptych). Oil on wood. Central panel 25 1/4 × 24 7/8 (64.1 × 63.2 cm); each wing 25 3/8 × 10 3/4″ (64.5 × 27.3 cm). *Source:* The Metropolitan Museum of Art, The Cloisters Collection, 1956. (56.70).

study of content is integral to an understanding of the work of art, and it will constitute an important aspect of your professor's lectures.

The Visual Description of an Image

The greatest challenge to a new art history student, however, is describing the visual properties of a work of art. At this point, you might be thinking to yourself, "I see why I need to learn the historical context of art, and I see why I need to understand content. But why bother describing an image when we are sitting right there looking at it!" The answer: because there is looking and then there is *looking.* One of the most important skills you can learn in art history is how to look at an image in an active, critical way. Are you a passive or active viewer? Test yourself by focusing on an image such as Jean-Auguste-Dominique Ingres' *Large Odalisque* (1814), a painting of a reclining nude (fig. 7). What do you see? If you are looking at it passively, you might have a hard time with this question, perhaps coming up with only a few descriptive adjectives—I have often heard it described in one-word statements like "perfect" and "beautiful." But if you are actively looking, you will be able to offer more specific information: the long, elegant proportions of the figure, the handling of different textures such as flesh and silk, and the glassiness of the canvas surface. You will be able to say why you think the image is "perfect." A first step toward this goal is to listen carefully as your professor describes a work of art for you. By example, she is showing you how to look.

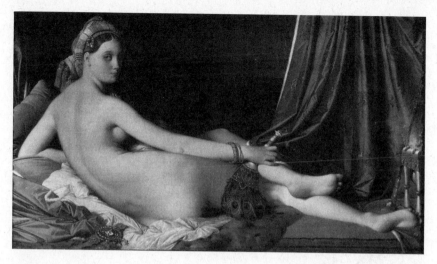

Figure 7 Jean–Auguste-Dominique Ingres, *Large Odalisque,* 1814. *Source:* Musee du Louvre, Paris/A.K.G., Berlin/SuperStock.

In describing the image, your professor will use a series of terms that are specific to the discipline of art history. In Chapter Three you will become more acquainted with these terms and learn how to use them in discussion and written work. For the moment, let's briefly go over some basic ideas that will help you with your first few lectures. Let's return to the *Nike of Samothrace,* a Hellenistic Greek sculpture dating to the second century B.C. (fig. 8). Your professor makes the following comments:

> The figure appears to be striking forward, with her right leg positioned in front of the left. She raises her wings high up to either side. Her drapery seems to stick to her body, revealing the cavity of her navel as well as an expanse of thigh.

Consider what we have just heard. Your professor discussed the position of the body and then proceeded to discuss the quality of the drapery. Note that Professors will generally use the term **figure** for the human body. Also, **drapery** is used for the simple, togalike dress commonly worn by figures in ancient and medieval art. Finally, note that special attention has been devoted to *how the drapery reveals the body underneath*—this is an important issue in art history, particularly of the pre-Renaissance periods. Hellenistic drapery, for example, is fluid and can even appear wet, drawing your attention to the underlying figure; by contrast, medieval art drapery will often appear stiff, folded into a series of patterns that do not respond to the anatomy of its wearer. While this may seem like a rather minor difference, it reflects two very different attitudes toward what is important and

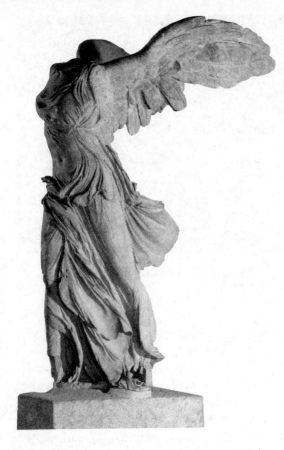

Figure 8 *Nike of Samothrace,* from Sanctuary of the Great Gods, Samothrace, c. 190 B.C. (?). *Source:* "Victoire de Samothrace," Musee du Louvre, Paris. © Photo RMN.

beautiful in art. For now, when you look at a draped figure in a painting or sculpture, ask yourself about how the drapery relates to the body, and the resulting effect. Your professor, I assure you, will appreciate it.

The Formal Analysis of an Image

The next component of visual information you need to identify is **formal analysis.** Your professor has described what is going on in the image: what the figure is doing, how it is standing, and its specific physical properties. That is all well and good. But what do all these properties add up to? What is their total effect? Often, nontrained students are hit with the effect first. Take another look at the *Nike of Samothrace* (fig. 8). You see drama and energy, and you can almost feel the sea spray soaking the figure's body. How long did it take you to react to the image? Probably not very long at all. In a split-second your eyes took in the work and your mind interpreted

it. For art historians, the question is, how did the work elicit your reaction? What makes the *Nike* dramatic? To answer this question, we need to examine the sculpture very carefully. We need to understand that our reaction to it was the result of a series of artistic choices, from the style of carving used to the positioning of the figure. That is where formal analysis comes in. *Formal analysis* is the study of *how a work of art comes together to create a certain effect.* Here is a formal analysis of the *Nike:*

> The *Nike*'s striding legs and outstretched wings create long diagonal lines that emphasize the energy and drama of the moment. Echoing these lines is the figure's drapery, which falls in large gathers along her legs, and creates patterns of light and dark that further energize the figure.

Here, the professor has made an assessment of how certain components of the *Nike* work together to create an effect on the viewer. The critical element here is that the discussion has turned from objective, matter-of-fact statements about the form, such as "the right leg strides forward, the wings are raised," to a consideration of how the form creates abstract patterns that shape the overall effect of the work and our reaction to it.

The Macrostatement and the Comparison

Once your professor has described and analyzed the work, she may very well make some comments about the characteristics it shares with other works of the same period. The *Nike of Samothrace* is characteristic of Hellenistic art, in which images of active, writhing figures and scenes of drama and emotion predominate. In this way, the *Nike* differs greatly with Greek art of the preceding era, known for its balanced and harmonious forms. So your professor might well conclude discussion of the *Nike* by stating how it is characteristically Hellenistic. This kind of conclusion I call a **macrostatement,** and it is important because it provides you with a specific example of what makes a work of art typical of its period. If you understand the basic characteristics of each period, you will be able to speak intelligently not only about works you are familiar with, but also about works you have never seen. There are practical benefits to this kind of knowledge: art history exams often include a component referred to as the *unknown* in which you are presented with a work that you have not studied.

Your professor, moreover, might make such a macrostatement by comparing one work with another from a different period. Let's take a medieval example: the west door (or **portal**) of the Cathedral at Chartres (fig. 9). This is a Gothic work from the twelfth century, showing Christ

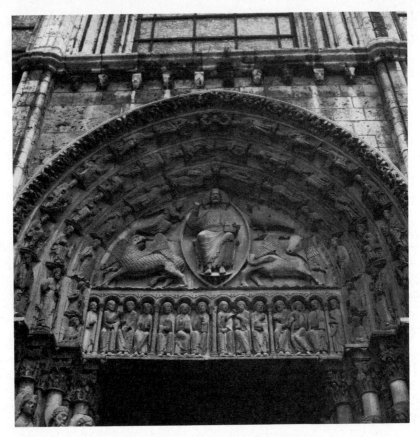

Figure 9 Central tympanum, west façade, Chartres Cathedral, c. 1145–1155.
A tableau of 12th century Shepherd. *Source:* Getty Images, Inc.

enthroned and surrounded by the Evangelists and their appropriate symbols: Matthew (a man or angel), Mark (the lion), Luke (the ox), and John (the eagle). Now let's compare it to another, earlier portal: that of the eleventh-century Romanesque church of Autun, also in France (fig. 10). Both depict Christ enthroned and surrounded by other figures, but the *formal* characteristics of each are very different. Here is how your professor might compare the two:

> At Autun, the composition seems disorderly: figures of different sizes and attitudes are scattered around the surface of the stone. By contrast, at the tympanum at Chartres, the figures are arranged in orderly tiers around the central figure of Christ. Proportions are also different: whereas at Autun, the figures are elongated, with sticklike, bent limbs and tiny heads, the figure of Christ at Chartres is more lifelike in proportions. Differences in the treatment of volume and space can also be seen. The Christ at Autun is virtually flat; the drapery is defined by

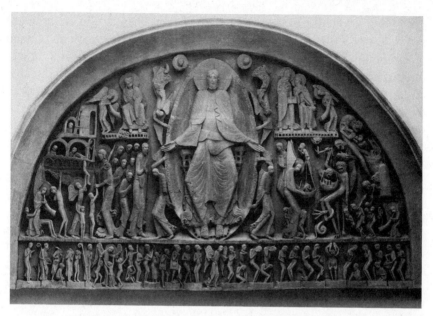

Figure 10 Gislibertus, *Last Judgement,* tympanum of west portal, Cathedral of Saint-Lazare, Autun, France, c. 1120–1136. Relief from the façade of Bulloz.

grooves that create linear patterns, pooling in concentric circles around the knee. At Chartres, however, Christ is liberated from the surface of the stone, and his drapery falls in lifelike folds around the solid volumes of his knees. Hence the twisting, distorted figures and linear patterns of the Romanesque have given way to the more natural proportions and greater visual clarity of the Gothic.

These kinds of comparisons are extremely instructive, because they show you how a period can be defined by contrasting it with another. They also illustrate what is important about each style—what visual properties are typical. Finally, they also give you a sense of the *evolution of forms*—in this case from the Romanesque to Gothic eras. The cross-period comparison is thus exceptionally useful for providing a broad view of the history of art. Since it is most likely that you will be asked to conduct such comparisons in exams and essays, it is important that you pay attention to the way your professor handles the task in lectures.

TAKING NOTES IN ART HISTORY

So far, we have discussed the anatomy of the art history lecture. But the question remains: how do you record this information in a useful way? This is one of the most serious problems facing students new to the

discipline. You will have attended many lectures before you are asked to take a test or write a paper. Even if you have a good textbook and intend on cramming before the exam, the information you are getting during lecture time is invaluable. The lectures, and particularly your professor's discussions and comparisons of the images, provide essential information for the exam that may not be replicated in the textbook. It may seem like an obvious statement for a professor to make, but I'll make it anyway: *go to all the classes.* Even if you are feeling under the weather, and even if you haven't done the reading, just go.

There is another thing to be said here. In a perfect world, professors would speak slowly and clearly, and students would be able to transcribe precisely all the important points made. Some may even give you a handout with the name and date of a work. But life isn't perfect, and there is nothing more frustrating than a professor who continues on to the next comment when you haven't finished writing down the last, or when you didn't quite catch the name or date of a work of art. You can probably find this information in your textbook or study guide. But if your professor tends to impart this information orally, it helps to have a system.

So how do you take notes? There is certainly more than one school of thought on the subject, and several different methods. One type of student take notes on everything, producing a perfect, clearly written transcription of all that is said. I know this type well, and there is nothing more distracting than sitting next to such a person and watching them in action—which, of course, ruins your own concentration! At the other end of the spectrum is the student who simply sits and listens. If asked about it, she will tell you that she finds it unnecessary to take notes because her memory is like a sponge. Sometimes such students are actually telling the truth.

Neither approach is advocated here. Even if you are lucky to have a fast hand and incredible powers of concentration, and can produce a volume of notes at the end of one lecture, it will be difficult to sort out this information when it comes time for the exam. If you haven't written *anything* down, your predicament is equally gloomy, because you have deprived yourself of a written record of the class. Sitting and listening to a lecture is hard work. It demands vigilance. If you are not taking an active role in the process, it is easy to slip into a passive role. This is in part because modern society has not trained you to work with images in an active way. Think about what happens when you watch television or go to the movies—are you really engaging your critical faculties when doing so?

So note-taking takes a little getting used to. The main goal, however, is for you to come away with an organized list of the slides shown and a

summary of the comments made about them. In the following section, you will learn a system for note-taking that produces a reliable and organized record of the art history lecture.

Organizing the Page

The first step is to think of your note page as two columns, reflecting the right-hand and left-hand positions of the slides shown in class. It may be that some slides are shown singly; however, for the sake of consistency, and because your professor will probably eventually compare the slide with another on the opposite screen, make sure to record its position to the left or right. As soon as a slide is projected, identify it with a star or some other kind of graphic device. Then write down its name and date, and any other of the vital statistics mentioned previously. Of course, your professor is not a robot and will probably not provide you with information in the same order for every slide. Just make sure to catch it when it comes. If you can't, and it is not appropriate to interrupt, just continue taking notes (perhaps by making an underline or question mark). Then, listen and watch as your professor begins to address the image. Is she talking about historical background? If so, write "HB" and then note, in abbreviated form, what is said. If she starts with a visual description and formal analysis of the image, again, write down key words and phrases. Let's take an example: the bronze doors of Andrea Pisano at the Florence Baptistery (fig. 11):

```
*  Bronze doors by Pisano, 1330-1336, Florence
   Baptistery of St. John

HB:

—13th-century Italy was a chaotic period
—the North dominated by wealthy city-states
—controlled by a few powerful families
—often fought each other
—but also were patrons of arts
—in North was emergence of artist as individual
—14th century saw idea of artistic competition
—artist submitted designs; one was chosen
—Pisano wins competition for doors of Florence
   Baptistery
```

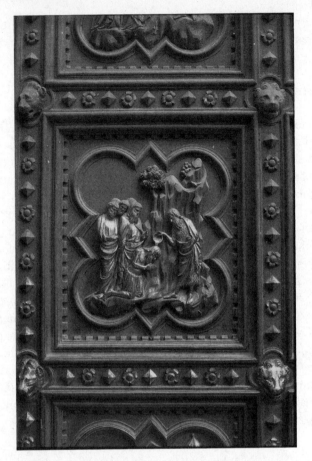

Figure 11 Detail of panel on South Doors of Florence Cathedral in Italy, called *The Baptism of St. John the Baptist,* 1330–1336, by Andrea Pisano. *Source:* Kim Sayer/Dorling Kindersley Media Library.

Now, your professor will move on to the visual component, describing the form and content of the image. Note this change of approach with a "V" for visual:

V:

—gilded bronze
—28 scenes from the life of John the Baptist
—quatrefoil (four-leafed) form

The Art History Classroom 27

Next, your professor shows you a detail from the same bronze doors: the *Baptism of John* (fig. 11) on the right projector. Record it in the right column. She now focuses on visual information:

```
* detail,

-figural groups seem balanced
-figures are 3-D
-lifelike proportions
-natural-looking drapery
-example: John's drapery
```

Note that your professor pointed out one part of the image: the drapery of John the Baptist, which falls in soft curving folds around the figure's body. This is an important element of Italian Gothic sculpture, and it is crucial that you note this observation.

Moreover, you will need to learn how to make such detailed observations yourself on exams and papers. They show your professor that you can make a visual argument. A good art history student can not only say that a figure's drapery looks like real cloth, but can point to *specific elements in the image that illustrate the point.*

There is another aspect of taking notes on images. Students, and particularly those in the visual arts, often ask whether it is useful to make small sketches of images during lecture. I believe that it is, provided that it takes no more than a few seconds and does not distract you from the comments of your professor. Even if you are not artistically inclined, it can be very helpful to capture the basics of an image in visual form. Although you might have access to images in your book or on a website, sketching them during the lecture can help to internalize them, an important advantage when it comes time to memorize images for the exam. Of course, some works of art lend themselves more easily to the process than others. The works of Impressionist painter Claude Monet and Abstract Expressionist Mark Rothko might be difficult to capture with your pen, because both artists were less interested in defining forms than in conveying properties of color and light. However, a Renaissance work like Raphael's *Madonna del Prato,* in which the figural grouping creates a clear triangular composition, can easily be recorded in your notebook. Ground plans of structures also lend themselves to quick sketches. *To keep them organized, place these drawings in the margins of your notebook page.*

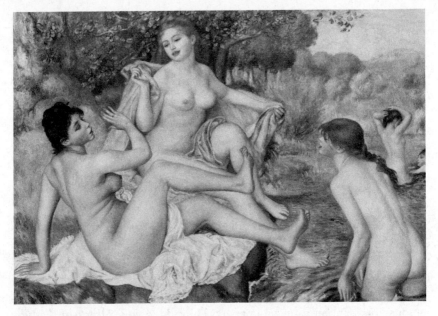

Figure 12 1963–116–13 Renoir, Pierre-Auguste, French (1841–1919), *The Great Bathers,* 1887. *Source:* Philadelphia Museum of Art. The Mr. & Mrs. Carroll S. Tyson, Jr. Collection

Note-Taking on Comparisons

Taking notes on your professor's comparisons is crucial, and again, the correct approach to recording this information will help you study later on. Also, it is a rare professor who does not repeat a comparison from a lecture in the exam—this is another important reason to record them carefully. So how do you go about it? Let's take an example: a comparison of an Impressionist painting, Pierre-Auguste Renoir's *Bathers* (1887) (fig. 12), and a work of modern art, Pablo Picasso's *Les Demoiselles d'Avignon* (1907) (fig. 13). Here are your professor's comments:

> Both of these works are representations of female nudes. Yet there are numerous differences between them. In the Renoir, the three women possess classic beauty—the soft modeling of the figures emphasizes the softness and suppleness of their skin, and their various poses allow us to see all views of the female body—a device that highlights their sensual appeal. The sense of sweetness and femininity is furthered by the palette of bright pastel colors, typical of Impressionist art.
>
> Very different is the representation of nudes in the painting by Picasso. Here, the soft, graceful curves of Renoir's young women have been replaced by sharp, angular forms. The figures do not

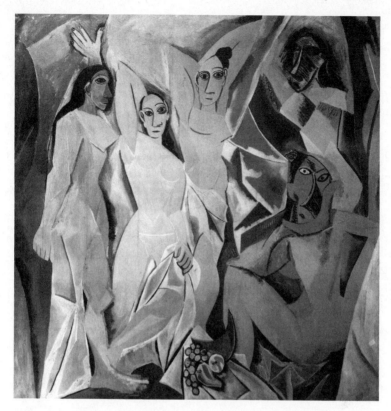

Figure 13 Pablo Picasso, Spanish (1881–1973). *Les Demoiselles d'Avignon,*
Paris (June–July 1907). Oil on canvas, 8′ × 7′ 8″ (243.9 × 233.7 cm).
Source: The Museum of Modern Art/Licensed by Scala-Art Resource, NY.
Acquired through the Lillie P. Bliss Bequest. Photograph © 2001 The
Museum of Modern Art, New York. © 2001. Estate of Pablo Picasso/Artists
Rights Society (ARS), New York.

engage in the coy play of the Impressionist painting; rather, they seem
to confront us directly and aggressively. In fact, their raised arms
convey a kind of frank sexuality that invites us to wonder whether
they are prostitutes. Gentle modeling of form has given way to harsh
outlines, and the pastel palette has been replaced by strong contrasts
of orange and blue. The palette, together with the forms and poses of
the figures, create together a violent image that is worlds apart from
the Renoir. The comparison thus illustrates a dramatic development
in the representation of women from the nineteenth to the twentieth
century, from a subject conveying feminine beauty and innocence to a
forceful, and somewhat intimidating view of the female nature.

So, how do you record this in your notes? This is where the double-
column organization of your page comes in handy. Write down the name

of each image and underline it. To indicate a comparison, write "vs." between the two ("vs." is the abbreviation for "versus," meaning "in contrast with."). Then write down the substance of the comparison. Shared features should go in the center of your page, between the two columns, while features specific to a single image should be placed in the appropriate column, like this:

```
* Renoir, Bathers, 1887    vs.    * Picasso, Les
                                     Demoiselles, 1907

                    both depict nude women
                             but

ideal female beauty
soft modeling
bright pastel colors;
can see all views of
   female
designed to arouse us
                             angular figures
coy play                     confrontational poses
                             prostitutes?
                             harsh outlines
                             sharp color contrasts
                             seems aggressive/violent
```

```
Macrostatement: In showing women as aggressive and
intimidating, modern art breaks with traditional
representation of women as sweet, beautiful (as in
Impressionist art).
```

Note the macrostatement at the end of the comparison. This is the most important note, because it tells you why your professor is drawing the comparison in the first place. Comparisons, as mentioned above, are used to show correlations, innovations, and artistic change. In any case, pay attention to the *why* of the comparison.

Architecture raises new possibilities in comparative work, inviting us to think about such issues as the organization and focus of space. A comparison of two medieval churches follows, one Byzantine structure from the sixth century and one Carolingian monument from the ninth.

Both the Carolingian church of Aachen and the Byzantine church of San Vitale in Ravenna are domed, **centralized structures** featuring

a two-shell plan, in which a series of supports separate the inner core from the outer aisle. However, the use of curving **exedrae** (curved columnar spaces) at San Vitale, as well as the mosaic decoration and the greater illumination from upper-story windows creates a space filled with movement. With its flat, rectangular piers, strong polygonal shapes, and massive arches, the church at Aachen seems much heavier and more ponderous. Aachen shows the way in which Carolingians transformed ideas from Rome and Byzantium to create a distinctly Northern aesthetic, which would shape architecture in medieval Europe up to the Gothic age.

```
* Palace Chapel, Aachen    vs.    * San Vitale, Ravenna

              both are domed, centralized
          both use supports to separate spaces
                         but

                              curving exedrae
                              mosaic
                              windows
                              columns on ground floor
                              create billowy space
at Aachen, the space is
  heavier
the piers are blocky,
  flat:
create flat interior
  space;
no ground floor columns
create heavier effect
```

> Macrostatement: Carolingian architecture uses older Byzantine forms but adds new local, Northern elements.

In this chapter, we have discussed the basics of the art history class. You have become acquainted with the format and the content of the lectures. You know how to organize and record the information presented to you. Still, if you don't take perfect notes for every lecture, don't feel overwhelmed or discouraged. Everyone, including your professor, has lapses of attention. Remember also that following a system of note-taking gets easier with time, and it will quickly become second nature. And if you are conscientious about it, the rewards will be great.

You have taken the first step toward success in the class. In the next three chapters, you will build on this success, learning how to participate effectively in an art history class, producing well-written and well-argued papers, studying for exams, and conducting research effectively and painlessly.

3

Putting Words to Images

Mastering the Response Essay

Students have often asked me how they could possibly spend more than a paragraph on describing of a work of art. This chapter will take you through the process, helping to you translate your visual observations into a well-written and well-organized response paper.

So, you have been asked to write your first paper for art history class. This is often referred to as a **description** or **response essay,** and it is a standard component of introductory art history courses. The assignment requires you to view a work of art and write your response to it. At first, you might think, nothing could be easier. Finally, a paper requiring no research, no footnotes, and no trips to the library! But the more you think about it, and the nearer the deadline approaches, the more anxious you get. Respond how? How am I going to come up with more than a paragraph by simply *looking* at a work of art? You glance at a poster in your dorm room and give it a try. All you can come up with are a few phrases: a garden with flowers . . . a group of people playing musical instruments . . . a table with a basket of fruit on it. Panic is setting in. What more can I say? And why is it so important, anyway?

As you will see in this chapter, one can say a lot more. Further, you'll find that learning to write about what you see is one of the most important skills you can acquire. As with all writing assignments, the response essay will certainly improve your writing. Trying to communicate an idea, and particularly a complicated one, is an exercise, and—as with physical exercise—it builds muscles—in this case, your "muscles" of articulation. For myself, I have often noticed that after a period of intense writing, the right words surface more quickly, and I am better able to convey what I mean both on paper and in conversation. But the description essay also has another benefit: it improves your powers of *seeing*. Once you starting writing about what you see, you will become more aware of the visual information surrounding you, and you will process that information in an active and critical way. And at a time in which we are constantly bombarded with images meant to inform, to persuade, to arouse, and sometimes to manipulate, what could be more important?

How can a simple writing assignment accomplish all this? By asking you to do something which might seem, at first, paradoxical. After all, looking at a work of art is a nonverbal, immediate experience. You view an image and take it in all at once. Writing about the image, however, means translating the act of looking into a series of written observations—that is, turning a silent, visual sensation into a verbal, sequential composition. That is the challenge: how do you go from looking to writing, while conveying a sensitive, accurate idea of the work of art? This will depend on (1) how closely and critically you observe the work of art in the first place and (2) how clearly you can communicate what you have seen to your reader.

This chapter is intended to help you with these particular tasks. It is not meant, however, as a comprehensive guide to art history writing assignments. For that purpose, there are two very good books to consider. The first is Sylvan Barnet's classic, *A Short Guide to Writing about Art,* 7th ed. (New York: Longmans, 2002), which is a complete guide to art history papers. The second is a more recent publication, Henry Sayre's *Writing About Art,* 3rd ed. (Upper Saddle River, NJ: Prentice Hall, 1998). Both books are extremely useful, but for the present purposes, both far exceed what you need to know in order to write the response essay. By contrast, this chapter will deal only with that particular task, taking you from your initial encounter with a work of art to the finished composition.

First, the basics. What is the response essay exactly? While it might vary slightly depending on your course and professor, we can still draw up a general definition. First, it is most often short, no more than five pages in length, and usually just two or three. Second, it focuses on a single

work of art. Unless otherwise instructed, you do not need to engage in lengthy comparisons with other works. Third, no research is necessary for this paper; do not concern yourself, for example, with a biography of the artist, or with a detailed discussion of the subject matter. Instead, focus simply on what you see.

Where do you find an appropriate work of art? This also varies from class to class. For example, if you attend a school within close proximity to museums, you will most likely be asked to visit an original work of art. In other locations, you may need to work from a photograph. On behalf of art history professors everywhere, however, I urge you to use an original if at all possible. In most cases, a reproduction can only provide you with a limited idea of the sense of a work of art. Details, textures, and scale, among other properties, will be difficult to apprehend when using a copy. In the case of three-dimensional works such as sculpture and architecture, the limits of photography become even greater, because you will only be able to see one view. For example, a building can be experienced from innumerable vantage points, and from both the interior and the exterior. However, do not despair: you can still write a good description paper— you will just have to be sensitive to the aspects of the work that might be missing in a reproduction or photograph.

WORKING IN THE "WHITE BOX": THE MUSEUM AND GALLERY EXPERIENCE

If you are going to be working with an original work of art, your professor will probably specify a museum or gallery to be visited. You will, of course, need to bring tools for writing with you. Keep in mind however, that museums often have special rules about what can and can't be brought into their spaces. If you are planning to bring a laptop computer, for example, call ahead to make sure that is permissible. If using more old-fashioned tools, you might want to bring a pencil, rather than a pen—some museums and libraries will prefer you work with the latter. Also, the pad of paper you use should be small, so that you can take notes comfortably standing up. The same holds true for a laptop. Physical comfort is important: you want to be able to spend at least thirty minutes concentrating on the *work*—not on how much your feet are bothering you. On the same subject, here is another important tip: make sure that you eat ahead of time, because most museums will not allow you to enter with food or drink. This might seem like rather silly advice to include in a book, but as you are probably aware, there is nothing worse than trying to work when you are hungry (particularly if you choose to work on a still life of fruit!). Your

concentration will be ruined, you will want to rush through the experience, and ultimately your paper will suffer if you do not attend to these small matters ahead of time.

It is also important to tour the museum by yourself. I find that many of my students like to go with classmates, often organizing and sharing rides. This is fine, of course, as long as you part ways when you enter the museum. If possible, choose different objects to view; if not, at least make sure that you *do not share ideas,* as tempting as it might be. The professor has assigned the paper in order to hear *your* individual response, not a group consensus. Moreover, he will certainly notice if your papers sound alike.

SELECTING A WORK OF ART

Solitary, and armed with your writing implements, you are ready to face a work of art. But which one should you work on? The answer varies from class to class. Some professors might actually assign you a work, or give you a list of objects to choose from. Others might give you free rein to choose something that falls within the parameters of the class. Make sure you understand what this means. For example, if you are taking a course in ancient and medieval art, do not choose a post-Impressionist painting for your response essay (students do this more frequently than you would think). Check the accompanying captions for relevant information about the date, period, and place of origin of a work of art. If you are still in doubt about your selection, ask your professor before beginning—you might save yourself a lot of wasted time.

Let's say you have been given the freedom to choose, and that you are aware of the kinds of works appropriate for your course. This is when you should consult your own instincts. As you walk into the exhibit space, don't try to be methodical. Let your eye scan the room, approaching objects that you are particularly drawn to. Allow your stream of consciousness to run free. What thoughts and feelings are stimulated by each work? Which intrigues you the most? It might not be the most aesthetically pleasing work of art in the room. My students often choose Egyptian sculpture. When asked why, they tell me that they are attracted to its sense of mystery and strangeness. Perhaps the work you have chosen evokes feelings of awe, fear, or sadness. Perhaps it raises certain ideas in your head, such as thoughts of motherhood, romantic love, or the supernatural world. Don't censor yourself—it doesn't really matter what sorts of thoughts or feelings the work elicits; the most important point here is that it engages you intellectually or emotionally.

Note that I said "engages you." Have you ever watched the behavior of crowds at a blockbuster museum exhibit? They plod sleepily along, sometimes harnessed with headphones, on a forced march from one famous work to another. It is a sad fact that those untrained in art history often do not really engage with images at all; instead, they get lost in a haze of passive, fuzzy appreciation. They stand in front of Monet's *Water Lilies* or Leonardo's *Mona Lisa* as if to catch magical rays of genius beamed from the canvases. In art history class, you will be shaken from that state of stupefied reverence and learn to *really look* at the images before you. You will become an active viewer. As Henry Sayre has written, think of art as "an address, an address that demands a response."[1] The following section will show you how.

RECORDING YOUR IMPRESSIONS

Having selected your work, it is time to take some notes. Begin by recording your initial impressions while they are still fresh in your mind. A sentence or two will do. Here are two examples:

> The painting makes me feel peaceful—it seems so serene. It looks like two big glowing clouds, and I want to walk right into it.

> The sculpture is so joyful—the way the woman holds the baby so close, and the way he looks up into her eyes. It makes me think about the bond between mother and child.

Note how in each case, the student concentrated on what feelings or ideas the work elicited. Try to be as honest, vivid, and original in writing down your thoughts. Avoid trite phrases or overt statements of judgment such as "the women in the picture are so pretty" or the "baby is adorable." Do not write that a work is "beautiful" or "glorious." Even if you find it so, you need to delve deeper into your own reactions and come up with more specific terms: is it serene? graceful? luminous? cheerful?

Next, write down the work's "vital statistics": its title, artist (if known), and date, which should be indicated on a caption adjacent to the work. If mentioned in the caption, you might also want to note down its place of origin (particularly with a premodern work). A word, by the way, on captions: theories about what to include in them vary greatly from

[1]Henry Sayre, *Writing About Art*, 3rd ed. (Upper Saddle River, NJ: Prentice Hall, 1998).

museum to museum. Some are terse, providing only the vital statistics of a work, while others are much more elaborate, including a wealth of additional information about the object. This information might be so interesting that you may wish to include it in your paper. Note it, certainly. However, the purpose of the response essay is for you to focus on the *visual* rather than the *historical* facts of a work of art, and this should be reflected in your final essay. And by no means should you include the text of the caption *verbatim* in your paper! Not only is this plagiarism, but take it from me—your professor will immediately know where you got the information! For further information on how to cite sources, see Chapter Five.

Having recorded the vital statistics of the work and your initial impressions of it, it is time to begin noting your visual observations, a process often called "prewriting." As the name suggests, this is meant to be a preliminary stage to writing the paper. Don't worry about elegant language or even complete sentences. Don't worry about finding some poetic metaphor for the work in front of you. Just focus on being as thorough, clear, and precise as possible. Why? Because these notes will provide you with "research material"—the notes from which you will compose your paper. To help you with this process, each paragraph below includes a series of questions for you to answer as you look at the work.

1. **Medium and materials.** Many students make the mistake of examining a work from an inch away before they have understood it as a whole. *It is crucial, however, that you start with the most elemental of observations.* What is the **medium** of the work? It might be one of the basic three, that is, painting, sculpture, or architecture. You might, however, have chosen a work of mixed media (such as collage), or more recent media, such as photography or digital art. Second, what kinds of materials are used? Is it oil on canvas? Is it made of basalt or polychrome wood? Is it a building made of reinforced concrete? Noting down the materials is not just information for information's sake. If we return to the idea of art as an address, we need to think of all aspects of the work as *words,* chosen deliberately by the artist in order to convey his or her message. In some cases, the message is more overt than in others. For instance, if we look at Renoir's *Bathers* (fig.12) we can see how the use of oil paint, a soft, "juicy" substance, works well with the subject matter of the scene: three young nude women cavorting by a riverbank. If the same image were executed in pen and ink, much of that sense would be lost. Then consider an ancient Egyptian sculpture, the *Khafre* (fig. 14), made of diorite, a hard, enduring stone. Think about how the materials themselves encouraged the creation of a simple geometric form, and how that form communicates a message of permanence and timelessness. Important note: whether or not you know for sure how hard or soft a material might be, its appearance alone should give you a sense

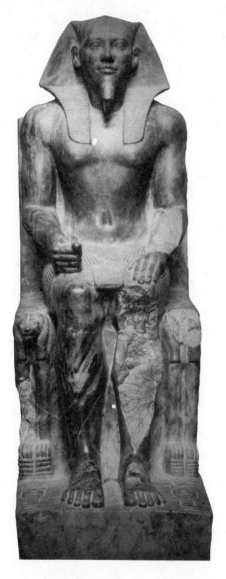

Figure 14 *Khafre,* from Giza. Dynasty 4, c. 2570–2544 B.C. *Source:* Egyptian Museum, Cairo.

of its nature. Remember, the paper is about your *perception* of the work. Now, turn to your work and answer the following questions:

1. What is the medium used?
2. What are the materials?
3. Do these elements shape the work's effect on you? How?
4. How would it feel if you touched the work? Would it be hard or soft? Prickly? Smooth?
5. Do you get a sense of different textures, such as cloth, skin, and hair?

2. Dimensions. Next, consider the dimensions of the work. In many cases, this information will often be listed on the museum caption, but if it isn't, don't worry. Estimate the measurements. Think about how the object appears in relation to you as the viewer. Then think about the subject matter. Is it a larger than lifesize human figure? Is it a medieval manuscript page of tiny proportions? Is it a gigantic **abstract** (*nonrepresentational*) sculpture? Think about how the size of the work affects the way you perceive it. Then answer the following questions:

1. What are the dimensions of the work?
2. What is the physical relationship between you and the work? Are you overwhelmed by it? Do you tower over it?
3. Does proportion play a role in the effect of the work on you? How?

3. Display of the Object. Now, consider how the object is displayed. Get as close to it as possible, remembering, however, that most museums have security devices that will be activated if you get too close. If you have chosen a sculpture, try to look at it from as many viewpoints as its placement will permit. Then walk away from it and view it at a distance. View it at different angles, and, if possible, in different lights. Think about how it was intended to be viewed. Does it have the most effect when you are near, at medium distance, or far away? Was it meant to be viewed frontally, or from the side? What kind of lighting is best suited to it? Pretend you are a museum curator, in charge of creating an effective display for the work of art.

If you are working with architecture, start by viewing the structure from the exterior. Does it have a clear focal point on one particular side? Does the exterior seem to invite you into the building? Then, if possible, enter the building. Is the structure best understood from the interior or the exterior? Note your observations. Here are some examples of such note-taking.

> This painting looks best when seen at medium distance. When I get too close, the brushstrokes are so bumpy that I can't see the whole thing clearly. From too far away, however, I can't see the details.

> This sculpture is big and simple in shape. But the shape changes in interesting ways as I walk around it. I think that its placement in the middle of the room is just right.

> This piece seems to make the most sense from straight ahead. The figure has erect, squared shoulders, and he is looking straight out—I feel like I should be right in front of him.

This building is best understood from the outside—I can understand where the tower is in relation to the surrounding sides of the structure. When I went inside, the wall decoration and the windows disoriented me. But outside, the organization of its different parts was made perfectly clear.

Have you ever noticed how some works of art seem to invite you to look at and react to them, whereas others seem to be more remote, existing in their own sealed world? Whichever type you have chosen (and many works lie somewhere in the middle), make sure to note if and how the work engages you. What attracted you toward it?

It is also important to be aware of the *original context* of a work of art; that is, the setting for which it was intended. When we look at works of art in museums, we are often dealing with objects that were once destined for other locations. A medieval altarpiece was intended for a church setting, while Egyptian sculptures were often housed in tomb chambers. Even a painting from the Impressionist era was initially placed in a gallery very much unlike the one that now houses it. A response essay may not require you to do any detective work in the area of original context, but keeping original context in mind will help you think about how you, the viewer, are intended to behold the image. Now, look at the work again and answer the following questions:

1. How is your object displayed?
2. From what angle should it be viewed? Why?
3. From what distance should it be viewed? Why?
4. How is it lit, and how does that affect your experience?
5. What is the original context of the work of art?

Formal Elements

It is now time for you to analyze the *formal* (or visual) aspects of your work of art, using the language of art history. Many terms of formal analysis are used in everyday speech, such as *line* and *color*. However, these words have specific and technical meanings when used in art history, and an important part of your success in the class is your mastery of them. The following sections are designed not only to explain the terms but also to show you how to use them in your paper.

***Line*.** One of the most basic art-historical concepts is line, and it manifests itself in many different ways depending on the work of art. In sculpture and

Figure 15 Frank Gehry, Guggenheim Museum of Contemporary Art, in Bilbao, Spain, 1997. *Source:* © FMGB Guggenheim Bilbao Museoa, 2002. Photographer: Erika Ede. All rights reserved. Partial or total reproduction prohibited.

architecture, we often speak of the **contour line:** the outline defining the perimeter of the shape. Think of the triangular contour lines of Egyptian pyramids, or the wavy, undulating contours of Frank Gehry's Guggenheim Museum of Contemporary Art in Bilbao, Spain (fig. 15). Or consider the contour lines of the prehistoric figurine known as the *Woman from Willendorf,* made of repeating semicircles (fig. 16). Contour lines also occur in two-dimensional works. Think about the lines that surround the forms, for example, in a painting such as Masaccio's *Trinity with the Virgin, Saint John the Evangelist, and Donors* (fig. 17). In modern abstract painting, lines work in a different way. For instance, Piet Mondrian's *Composition with Red, Blue, and Yellow* (1930) (fig. 18) consists of strong vertical and horizontal lines creating a geometric design that denys any sense of depth.

Lines are powerful not only because they define shapes and order images, but because they also serve to direct your eyes, whether in architecture, sculpture, or painting. Remember the way line works in the *Nike of Samothrace* (fig. 8). The upraised wings of the figure and the folds of the drapery create two intersecting diagonal lines across the body of the figure. Now consider a sixteenth-century Flemish painting, the *Return of the Hunters* by Pieter Brueghel the Elder (fig. 19). On this two-dimensional

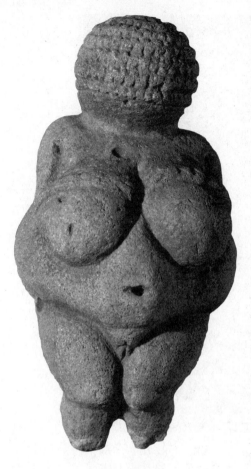

Figure 16 *Woman from Willendorf,*
Austria, c. 22000–21000 B.C.
Source: Erich Lessing/
Naturhistorisches Museum, Vienna,
Austria/Art Resource.

surface, how are lines used? As Marilyn Stokstad has commented,

> The sharp diagonals, both on the picture plane and as lines receding
> into space, are countered by the pointed gables and roofs at the lower
> right as well as by the jagged mountain peaks linking the valley and
> the skyline along the right edge. Their rhythms are deliberately
> slowed and stabilized by a balance of vertical tree trunks and hori-
> zontal rectangles of water frozen-over in the distance.[2]

Note how strongly line works in this image to direct your eye, affecting
the whole composition and your experience of the work.

In most cases, the use of repeating lines at right angles conveys a
sense of stability. Strong diagonals, on the other hand, often create tension

[2]*Art History,* 727.

Figure 17 Masaccio, Italian (1401–1428), *Trinity with the Virgin, Saint John the Evangelist, and Donors.* Fresco in the Church of Santa Maria Novella, Florence, c. 1425 (?). *Source:* Alinari/Art Resource.

and suggest motion. Consider another example: Jean-Louis David's *Oath of the Horatii* (1784–1785) (fig. 4), a painting depicting three Roman brothers (the Horatii) swearing an oath to their father to fight to the death for Rome. Note how the raised arms of the three brothers at left create an emphatic diagonal line that is countered by the upraised gesture of their red-cloaked father. But the effect is not of uncontrolled energy. David is known for his careful, balanced **compositions;** note how the diagonal lines in the image are stabilized by the triple-arched backdrop of the image.

Let's turn to architecture. Think about a Greek temple, such as the Parthenon on the Acropolis in Athens, dated to the sixth century B.C.

Figure 18 Piet Mondrian (1872–1944), *Composition with Red, Blue, and Yellow,* 1930. 51 × 51 cm. (Private Collection). *Source:* Giraudon/Art Resource, NY/© 2004 Mondrian/Holtzman Trust, c/o Beeldrecht/Artists Rights Society (ARS), New York.

(fig. 20). What are its predominant lines? A series of uniform verticals (the columns) complemented by a continuous horizontal (the **entablature**). How does this arrangement of lines differ from, for example, the Guggenheim museum in Bilbao? In the building by Frank Gehry, the building contains, it seems, almost no right angles, using instead curvy, wavy forms. How does the difference in line affect your experience of the two buildings? The former, with its uprights and horizontals, seems stable and planted in the ground, while the modern building seems to move, to undulate.

In two-dimensional arts, as mentioned, line is also used primarily to describe or outline shapes. But the illusion of **volume** (or roundness) can be also indicated through the use of lines, as in the use of **hatching** (short, sharp strokes that create shadows). Moreover, lines can be uniform and

Figure 19 Peter Bruegel the Elder, Flemish (c. 1525–1569), *Return of the Hunters*. 1565. Oil and tempera on panel, 46 × 63 3/4 in. *Source:* Kunsthistorisches, Museum, Vienna.

Figure 20 Kallikrates and Iktinos, Parthenon, Acropolis, Athens, 447–438 B.C. *Source:* Photographer: Paul W. Liebbardt.

Figure 21 *Page Depicting Mark the Evangelist, Ebbo Gospels,* c. 816–840. *Source:* Bibliotheque Municipale, Epernay, France. Art Resource, NY.

sharp, as in the example of Mondrian's *Composition with Red, Blue, and Yellow* (1930) (fig. 18), or fuzzier and of inconsistent thickness, as in Monet's *Water Lilies, Giverny* (fig. 1).

If you think that the choice of lines does not affect your experience of a work of art, consider a page from the medieval manuscript known as the *Ebbo Gospels* (816–840) (fig. 21). It depicts the *evangelist* Mark seated in a landscape. Line, more than any other formal component, dominates the image. Instead of using shading or modeling to define drapery folds, the artist has depicted a figure bathed in swirling, undulating lines. The saint's hair is a mass of wildly curving strokes, and even the landscape is composed short, curved hatchmarks. The use of these marks serves to energize the image—it has often been referred to as having a "nervous linearity."

This nervousness and dynamism, moreover, is a perfect visual counterpart to the subject matter of the painting: the saint is depicted just as he is divinely inspired to write down the word of God. Think about the work of art you have selected and ask yourself these questions:

1. What are the dominant lines of the work?
2. If sculpture or architecture, what kinds of contour lines are created?
3. Do the lines suggest movement and direction? Or do the forms seem planted in the ground?
4. To where do the lines lead your eye?
5. If you are dealing with a two-dimensional work, are the lines thick or thin?
6. Is their width consistent?
7. Are they straight or wavy?
8. Are they predominantly vertical, horizontal, or diagonal?
9. How does line contribute to the overall effect of the work?

Shape and Space. As you answer the previous question, you will also find yourself confronting a related issue: **shape** and **space.** What do we mean by shape? Based on its common English definition, you probably already have a good idea. But it can also be defined, for our purposes, in a more technical way: for three-dimensional works such as sculpture and architecture, *shape* is defined by the *physical contours of the form.* In the case of the pyramids at Giza, for example, we are speaking of an object that takes up space and thus has *volume.* In the case of two-dimensional works, shape is defined by lines, or sometimes edges of color. It exists on a flat plane (such as a canvas or photographic sheet) only in width and height. In abstract art, as in a work by Mondrian or Jackson Pollock, the quality of flatness is often emphasized: we are to understand shapes as surface elements. However, artists will often manipulate shape in order to convey a sense of three dimensions. In painting, one of the most frequent ways to suggest this is by the use of tonal gradations or **modeling,** in which shadows and highlights simulate the effects of light bouncing off an uneven, projecting object. Shapes, moreover, can be classified as either *geometric,* as in the case of the Giza pyramids, or **biomorphic,** which refers to natural forms, such as human figures, animals, and plants.

1. What shapes are used in your work?
2. If it is a two-dimensional work, has the artist suggested a three-dimensional shape?
3. How is this done?
4. If sculpture or architecture, what form does the shape take?

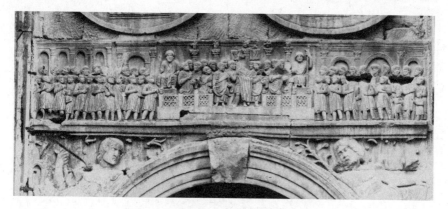

Figure 22 *Constantine Speaking to the People,* relief panel from the Arch of Constantine, Rome, 312–315 A.D. *Source:* Alinari/Art Resource, N.Y.

Space. So far, we have talked about the definitions of solid shapes. We may refer to these as *positive* shapes. But there are also shapes created by the absence of solids. These can be referred to as **negative shape,** or *space:* the void located between or around solid shapes. In sculpture and architecture these spaces are real. In two-dimensional art, however, space, like shape, is only implied. Now at this moment you may wonder, "Why all the fuss about something as insubstantial as space?" As with line, however, space can have a powerful effect on a work of art and your experience of it. For example, it can create dramatic optical effects in sculpture. Consider the fourth-century reliefs on the *Arch of Constantine* (fig. 22). Here, short, stubby figures stand in a row across a long horizontal plane. Between each of the figures' legs are shadows, roughly the same width as the legs themselves. Hence a uniform pattern of light (made by the figures' legs) and dark (made by the spaces between them) is created, and thus a kind of visual rhythm is established.

Space can also be used in more metaphorical, expressive ways. This is illustrated in a work of classical Greek art: Consider the *Woman and Maid,* a painting on a *lekythos,* a slender, one handled vase, dated to 450–440 B.C. (fig. 23). The vase depicts a servant offering a box of jewelry to her mistress, the deceased. Although in close proximity, the two figures do not look at each other. There is a clearly perceptible, roughly triangular void that separates them, painted white like the rest of the background. In its sharp outlines, and placement *between* the two figures, this space emphasizes the sense of loss inherent in the theme of the work.

Because the vase contains only minimal indications as to the setting of the two figures, it is impossible to discern whether the void that separates them is shallow or deep. Yet in many two-dimensional works,

Figure 23 Style of Achilles Painter, *Woman and Maid,*
white-ground and black-figure decoration on a *lekythos,*
c. 450–440 B.C. *Source:* Museum of Fine Arts, Boston.

one may often discern different layers of **pictorial depth,** a term referring
to the recession of space into the distance. If we look at a landscape, for
example, we can immediately sense which elements of the painting are
closest to us and which are farther away. Yet, we are, of course, looking at
a flat surface. The space that seems closest to us is referred to as the
foreground, that which seems farthest is referred to as the *background,*
and that which is between them is called the *middle ground.* Artists will
manipulate these elements in order to control the way you experience an
image. For example, note how in the *Oath of the Horatii* (fig. 4), David
has positioned the action in the foreground. An arcade situated immedi-
ately behind blocks any further recession into space and creates a shallow,
stage-set effect, highlighting the dramatic content of scene.

Figure 24 *Cityscape,* detail of a wall painting from House of Publius Fannius Synistor, Boscoreale, late 1ˢᵗ century A.D. Wall painting from the Cubiculum of the Villa at Boscoreale: Panel II. Fresco. *Source:* The Metropolitan Museum of Art, Rogers Fund, 1903. (03.14.13a-g).

How is depth created in a two-dimensional image? There is no single answer to this question. Artists from different eras and cultures have conveyed the idea using a variety of methods. To demonstrate this, let's compare the following two works: the ancient Roman wall painting entitled *Cityscape* (fig. 24) and the *Trinity* by Masaccio from fifteenth-century Italy. Both are meant to give the impression of pictorial depth or **perspective,** but do so in different ways.

Let's start by looking at Masaccio's *Trinity* (fig. 17). Let your eyes follow the diagonal lines created by the figures and by the architecture. Note that the barrel vault above the figural group contains a series of diagonal lines. In your mind, extend them back into the depths of the

image. You have probably noticed that all these lines, called **orthogonals,** intersect at a single point, referred to as a **vanishing point,** just above the base of the cross. This method of conveying depth, referred to as *scientific perspective,* was invented during the Renaissance and is characteristic of the postmedieval art of Western Europe.

Turn now to the *Cityscape,* a detail of a wall painting from the House of Publius Fannius Synistor, Boscoreale, and dated to the late first century A.D. Here too, allow your eyes to follow the orthogonals, and extend them toward an imagined vanishing point. You will immediately notice that not all the diagonals lead to the same point—rather, each leads in different directions. This system, frequent in ancient and medieval art of the West, is referred to as *intuitive perspective,* because it is based on the intuition or sensation of depth rather than on a scientific system.

Most people new to the study of art history make the mistake of assuming that scientific perspective is somehow superior. However, such qualitative judgments are rarely useful. Even if we agree (and we might not) that scientific perspective replicates most closely the way things seem in nature, this doesn't necessarily mean that the method is superior to any other. *What makes close imitation of the natural world superior to a more abstract or subjective expression?*

There are many additional ways to show depth. For example, on a two-dimensional plane, depth can be conveyed by placing the nearest figures lowest on the page and those farthest at the very top. Space is thus created by the stacking up of forms. This is referred to as *vertical perspective,* and is commonly found in pre-Renaissance and non-Western art. Another way to indicate spatial distances is to use *overlapping,* in which one form is placed in front of another. **Diminution,** in which the farther object is made smaller, is also a frequent means to convey depth. Finally, elements of line, light, and color might also be brought to use, as in the case of *atmospheric perspective.* This method is based on the observation that the closer an object is to the viewer, the sharper its outlines and more intense its color. Objects placed farther away lose their strong contours and hues, becoming faded and blurry.

Now consider the use of space and shape in your work and answer the following questions:

1. If you are working with a two-dimensional work, what are the shapes present?
2. How are mass and volume conveyed?
3. How is negative space conveyed?
4. Has the author used these forms to further his message (as we saw in the *lekythos*?)

5. Is the work open or does it seem more solid?
6. Is spatial recession conveyed and if so, how?
7. How does the artist's treatment of shape and space inform your experience of the work?
8. If you are dealing with architecture or sculpture, what are the dominant forms?
9. Are they biomorphic or geometric?
10. Is there any empty space, and how does that affect your experience?
11. Does the empty space make the object look more fragile or is does it seem strong and sturdy?

Composition and Relative Scale. We have considered the concept of shape and space in your work of art. But in order to understand your work, you must consider how these elements come together as a whole. The organization and arrangement of forms is referred to as *composition,* and this greatly affects the meaning of a work of art, controlling your visual focus and highlighting particular elements of the whole.

To discern the composition of a work, it is important to be able to see underlying formal structures. In the case of abstract art, the process is easier: you should be able to pick out the dominant forms and the way they are organized. A representational work, however, is more challenging to work with. For example, instead of seeing the figure of a woman, you must try to see her as a collection of cylinders, spheres, triangles, or whatever shapes she is composed of. How best to achieve this? The trick I learned in high school drawing class is particularly effective: turn the work upside down or sideways—your mind will be less ready to pick out identifiable shapes and think "arm" and "leg," and will focus instead on the pure formal properties. Of course, this trick is not advisable if you are working with a museum object! However, try squinting or turning your head—you will be less likely to be distracted by the subject matter. At this point, the composition will become clear to you.

Why is composition an important concept? Like the other formal elements we have considered, the way forms are arranged in a work often creates the overall message. To understand how this works, look at the medieval tympanum at Chartres Cathedral (fig. 9). Now, turn the book upside down. Forget that you are viewing Christ surrounded by evangelist symbols, apostles, and prophets. Think about these figures as abstract forms instead. How are they organized? You will notice that the composition is made up of one large figure at the center of the composition. Moving out from the center are slightly smaller figures. Turning to the **archivolts,** or the arched frames of the portal, the figures have become even smaller.

With these observations about composition, we can now "remember" who we are looking at. Notice how the central form, that of Christ, dominates the composition. Not only is he placed at the center of the image, but he is also the largest figure on the tympanum, and is framed by the other figures. These compositional choices organize the image, but they also serve another function: they illustrate a hierarchy in which Christ assumes the most important position. Indicating importance by manipulating the **scale** of figures and using a centralized composition with framing elements is typical of many premodern and non-Western artistic traditions.

Now think about how forms are arranged in painting. Let's turn back to Masaccio's *Trinity* (fig. 17). Again, put side the identity of the figures and concentrate on the composition they create. Notice how the two central figures create a solid, stable anchor for the composition, which is framed symmetrically by the two kneeling figures nearest to them. This framing element is furthered by the two donors at either sides of the composition. The symmetry and solidity of the composition, moreover, is emphasized by the massive barrel vault that houses the figures and by the stone base which supports them. Note, then, how the placement of figures symmetrically around a central component and the use of horizontals and verticals (instead of diagonals) conveys a sense of solidity and stability.

Now consider a Baroque painting: the central panel of *The Raising of the Cross* by Peter Paul Rubens (1609–1610) (fig. 25). As with Masaccio's painting, the image depicts a group of figures surrounding Christ on the cross. However, here we see the moment just before the Crucifixion, when the cross is hoisted to an upright position by a group of muscular soldiers. The figure of Christ creates a strong diagonal from the lower right to the upper left, which is highlighted also by the pale nude colors of his flesh and of those immediately around him. Unlike the composition of Masaccio's *Trinity*, with its anchored, centralized composition, here we have a sense of imbalance and tension—as though the central unit of figures would topple at any moment. This sense of tension is in keeping with the themes of the work: intense emotion and physical suffering. Now, think about the composition of the work you have chosen to describe, how it affects your experience, and how it relates to the subject matter depicted.

1. How do the various formal elements interact?
2. Does the relationship convey the unity of the forms? How?
3. Are all the forms clustered toward the center, or are they balanced at either sides?
4. Is the composition symmetrical?

Figure 25 Peter Paul Rubens, *The Raising of the Cross,* c. 1609–1610. *Source:* Cathedral of Our Lady, Antwerp/SuperStock.

5. How is emphasis achieved through form?
6. What is the focal point of the composition?
7. How is this focal point created?
8. What is the theme or idea conveyed by the focal point?

Light and Color. So far we have talked about the solids and spaces that define the work you are describing. These, as you have already noted, affect the way you perceive the painting and the message it communicates to you. But the shapes and spaces that you see may also be informed by two more principles: *light* and *color.*

Let's begin with light. This element affects both two- and three-dimensional works, but it is most affecting when it appears in two-dimensional work such as painting. Often, light is used to convey the volumes of solids. For example, in Renoir's *Bathers* (fig. 12), we can see how highlights, in combination with shadows, give a sense of roundness to the objects.

This, however, is a rather broad generalization. In fact, artists of different eras used light in various ways. In the Venetian Renaissance, artists

suffused their paintings with clear, golden, evenly distributed light, whereas the Florentine artist Leonardo used more heightened contrasts between light and dark—a technique referred to by the Italian term **chiaroscuro,** which translates, literally, as "light-dark."

In some works, light creates more dramatic power than any other element. Consider, for example, Georges de la Tour's *Repentant Magdalen* (c. 1640) (fig. 26). Here, the seated Mary Magdalen sits at a desk, resting her head in one hand and touching a skull with the other. Behind the skull is a lit candle, which casts strong light on her profile and arm. The rest of the room is thrown into darkness. This creates a theatrical effect, effectively spotlighting the woman as the subject of the painting. But light also

Figure 26 Georges de La Tour (1593–1652), *Repentant Magdalen,* c. 1640. "Madeleine a la Veilleuse" (Penitent Magdalen). Oil on canvas, 128 × 94 cm. *Source:* Louvre, Paris, France. Copyright Erich Lessing/Art Resource, NY.

plays an important role in the meaning of the work as well. Not only are we directed, through the use of light, toward the woman, but we meditate on her, on the ephemerality of the candle, on the skull before her, and on the void lying outside of that small, lighted space. Think of how different the piece would be if the whole room were "lit up" by the artist!

1. What role does light play in the work you have selected?
2. Is it uniform and gentle? Or dramatic and theatrical?
3. Where does it lead your eye?
4. Is it disturbing or comforting? Why?
5. Does it help to convey the message or theme of the work? How?

Color, also called *hue,* can also play an important role in a work of art. To understand the effects of color in the work you are responding to, you need first to master some technical knowledge on the subject: there are three primary colors—red, yellow, and blue. By mixing them in various combinations, you arrive at the secondary colors: green, yellow, and purple. Moreover, each of these colors can vary according to its *value* (degree of lightness or darkness), and *intensity* (degree of saturation). To visualize this, think of the difference between the color of an emerald and a stalk of celery.

Often, the choice of colors, or *palette,* of a work of art sets a particular mood. Reds, yellows, and oranges are often referred to as warm or hot colors, whereas blues, greens, and purples are cool. In his painting *Water Lilies, Giverny* (fig. 1), Monet used a wide range of blues and greens, emphasizing the serenity and stillness of the watery gardens. In Picasso's *Les Demoiselles d'Avignon* (fig. 13), however, the artist has reduced his palette to a sharp contrast of acid orange and light blue, lending the scene a mood of aggression, if not violence.

While some artists use color to convey the accurate hue of an object, artists from the Impressionists onwards begin to experiment and depart from the *local* (or authentic) *colors* of an object. Monet placed blues and reds in fields of hay to simulate the optical effects of looking out into the distance in bright sun. Picasso, on the other hand, used green in the hair of his mistress. Now, think about the palette used in the work you are examining:

1. What is the dominant palette of your work? Warm or cool colors?
2. What is their value?
3. What is their intensity?
4. Is color used to help convey the work's theme or message?
5. Does it add drama or tension, or is it calming?

Style. **Style** is the final component for you to consider as you take notes on your chosen work of art. What do we mean by style? Don't confuse it with the popular definition—it has nothing to do with being fashionable. Style is a technical term with specific application in the field of art history, referring to the way in which the artist presents his or her subject to you. Style is a question of *how* the artist achieves his or her presentation. In painting and sculpture, there is a *representational* and *nonrepresentational* style; the former depicts views or objects recognizable in the world, and the other is *abstract*—depicting forms and shapes that originate in the mind of the artist. Style also refers to the way in which forms are presented. Are they defined primarily by line? In this case, you may call the work **linear.** The *Page Depicting Mark the Evangelist* in the *Ebbo Gospels.* c. 816–840 (fig. 21) is a work in which ink is used to define forms. It is an excellent representative of the linear style. However, paintings too can be linear. Consider, for example, the work of Jean-Auguste Dominique Ingres, a neoclassical painter and student of the famous neoclassical artist Jean-Louis David. In Ingres' painting *Large Odalisque* (1814) (fig. 7), depicting a reclining nude woman, the canvas surface seems smooth and glassy, and distinct lines define the contours of the figure, the pleats of the drapery, and the dark void beyond. Pierre-Auguste Renoir, on the other hand, used a **painterly** style. In his *Bathers* (1887) (fig. 12), the artist used a brush loaded with paint and applied it to the canvas in loose strokes, endowing the forms with soft modeling rather than sharp outlines.

The elements of style presented to you thus far probably seem straightforward. However, students often get confused by four additional concepts: **realism, naturalism, idealism,** and **abstraction.** Let's begin with the first. What is *realism*? Consider the example of a late Roman portrait of the emperor *Caracalla,* dating from the early third century A.D. (fig. 27). Pay attention to the way the face is handled. It is that of an individual; we see the wrinkles and furrows on the forehead, the folds of skin linking the nose to the mouth, the prominent cleft chin, and even the emperor's stubble. All of these details convey the sense of a real person; one can imagine walking by such a figure on the street. So, *realism* is the attempt to depict objects exactly as they are in actual visible reality, "warts and all."

Like realism, *naturalism* is also based on the representation of the physical world; in this case, however, artists look to nature only for inspiration, rather than trying to achieve precise imitation. For an example, let's turn to the Corinthian **capital,** an element of Greek architecture (fig. 28). Consider the plant forms sculpted around its base, referred to

Figure 27 *Caracalla,* early 3rd c. A.D. Portrait head of the Emperor Caracalla (A.D. 211–217). Marble, bust, Roman III Century A.D. *Source:* The Metropolitan Museum of Art, Samuel D. Lee Fund, 1940.

as **acanthus** leaves. Note that they seem to bend and curve around the capital, conveying a sense of real, organic life forms. They appear to be growing right out of the capital. Certainly, the forms are somewhat patterned—the artist has arranged them symmetrically to conform to the circular base of the capital. But they are still recognizable as forms found in nature.

Naturalism might also have to do with the way a figure is rendered, as in, for example, Greek sculpture. Let's consider a work of early classical sculpture, the *Doryphoros* (fig. 2), a portrait of a young athlete in the nude. Note how the artist has paid attention to details of the anatomy, such as the little flap of muscle above the knee, seemingly suspended by the skin. Note also the way the figure stands, with his weight shifted onto his left leg. Attention to anatomy and to lifelike movements of the body

Figure 28 Corinthian capital. Carved leaves. *Source:* Dorling Kindersley Media Library.

are also elements of naturalism. But is this a particular man, someone you might run into in a restaurant or store? It is hard to say. What are his distinguishing features? He has no wrinkles, freckles, or asymmetries—those "irregularities" which distinguish us from each other and make us unique individuals. There is no hint of a facial expression to convey a specific state of mind or mood. This makes the *Doryphoros* an example of naturalism rather than *realism.* It is a work *inspired* by the appearance of an actual young man, but not a precise record of that man. Drapery or clothing can also be termed as *naturalistic* if it hangs over the body in a believable way.

Idealism and abstraction are more conceptual. In the case of *idealism,* the work of art is meant to communicate a kind of visual perfection or beauty. It is important here to remember that beauty is not an absolute idea, but shifts from culture to culture—Victorian ideals of female beauty, for example, are quite different from those of modern Japan. In Greek sculpture, idealism was often conveyed through representations of the human figure such as the *Doryphoros* (fig. 2). Now, you might be confused at this point: didn't I just use this work as an example of naturalism?

Figure 29 *Menkaure and his Wife, Queen Khamerernebty,* from Giza, Dynasty 4, c. 2515 B.C. Slate.
Source: Museum of Fine Arts, Boston.

Isn't it inspired by nature? The answer is yes and yes. But in Greek society, the youthful athletic human figure, rendered in a naturalistic way, was considered the epitome of what was good and beautiful. Its sculptor, Polykleitos, devised a mathematical formula in order to produce the ideal male form, and the *Doryphoros* was intended as a representation of it. So the *Doryphoros* is an example of both *naturalism* and *idealism*.

In the royal portraiture of ancient Egypt, we also encounter idealism. Here, too, the figures are represented as young and strong, with broad shoulders, a slim waist, and muscular limbs. However, instead of the relaxed stance of the Greek sculpture, the Egyptians preferred to depict their ideal figures as rigid, frontal, and erect, as in the sculpture *Menkaure and his Wife, Queen Khamerernebty* (fig. 29).

Abstraction is another way to describe artistic style. In this case, the artist is less interested in the careful recording of how things look in nature, and more interested in a certain visual property or pattern. Let's take an example from prehistoric art, the *Woman from Willendorf* (fig. 16). We can certainly recognize that this is a heavy-set woman, and we can distinguish the different parts of her body. Yet, we can also note that the representation is not perfectly true-to-life, but has been manipulated. Note the exaggerated solidity and roundness of her breasts, belly, and thighs. The other parts of her body, by contrast, are virtually unrecognizable: the face is entirely obscured, and her minuscule hands are only just visible above the breasts. In this way, the artist transformed the female body into a pattern of repeating round forms. The artist's method of abstraction, moreover, emphasizes a single idea; the round belly, breasts, and thighs convey the fertility of the female—an important message in a era when the average life expectancy of humans was around 35!

In some works, however, there is no recognizable relation to subjects found in nature. Such works are referred to as **nonrepresentational** or **nonobjective** art. Twentieth-century art offers many examples of this style. Consider Mondrian's *Composition with Red, Blue, and Yellow* (1930) (fig. 18). Here, we are confronted with a series of colored squares, large and small, connected by a grid of black lines. The artist has turned away from the naturalistic to concentrate primarily on geometric forms, sharp contrasts of color, and repeating patterns. It would be a mistake, however, to assume that the picture is empty of meaning because of the absence of a recognizable subject. In fact, we know that Mondrian viewed his compositions as metaphors for an ideal society, in which the use of colors and balanced forms represented individuals living in harmony. But an exploration of subject matter, after all, is not the aim this chapter. Rather, it is to make you aware of the different styles that an artist can adopt to communicate his or her ideas.

Another artistic style is called **expressionism.** In this case, the work might be naturalistic, abstract, *or* idealistic—expressionism refers to any work that appeals to the emotions of the viewer, often in an exaggerated or theatrical way. Twentieth-century art provides us with many examples of expressionism, and these often also feature elements of abstraction. Perhaps the most famous is Edvard Munch's *The Scream* (1893) (fig. 30). In this case, a man stands in the foreground of a landscape, holding his hands to his head and crying out. The eyes and mouth of the man are enlarged, and lines radiate around the figure, focusing our attention on his disturbed psychological state. Even the landscape, with its wavy horizon lines, seems to reverberate with anxiety. Note how line is used here, as in the *Ebbo Gospels* (fig. 21), to convey drama and mood.

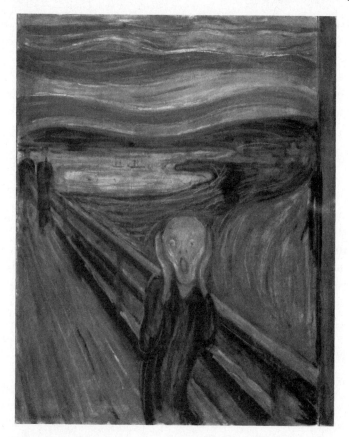

Figure 30 Edvard Munch, *The Scream,* 1893. *Source:* Oslo,
National Gallery. Scala/Art Resource, NY. © 2004 The Munch
Museum/The Munch–Ellingsen Group/Artists Rights Society (ARS),
New York/ADAGP, Paris.

Abstract Expressionism is a specific period unto itself, and refers
to a school of painting and sculpture active in New York between 1940
and c.1960. In the work of Jackson Pollock, for example, *representational*
forms have been abandoned in favor of rhythmic splatters and drips of
paint, records of the dynamic and expressive gestures of the artist.

Now consider the work you have chosen to explore and ask yourself
the following questions:

1. In what style is your artist working?
2. Do you see elements of abstraction? What are these elements?
3. What do you think the artist meant to convey through his or her
 abstraction?
4. Is it a naturalistic form? To what extent is it inspired by nature? To
 what extent does it depart from nature?

5. Is it a realistic form? What makes it realistic? What seems "real" about it?
6. Is it an ideal form? How do you know? What makes it characteristic of ideal beauty? And if so, to what culture does it belong?
7. Is it expressionistic? Does it appeal primarily to your emotions? Which emotions and how?

Before leaving the museum, it is useful to draw a small sketch of the work. This is mostly for your benefit; it doesn't matter if you feel you are a gifted artist or not. The purpose is to get you to look carefully at the work, and sometimes the best way to do this is through recording what you see in visual as well as verbal terms. A sketch will also be a useful resource to return to as you write the paper. If a photographic reproduction of the work is available, however, either from a website, a book, or in the form of a postcard, you should obtain that as well, and if possible, include it with your paper.

WRITING THE PAPER

Having examined the work of art closely, answered the above questions, and drawn a thumbnail sketch, you are ready to begin the process of composing your paper. To do so, find a quiet, comfortable place to write. This might be your dorm room, the library, or even a café—the main thing is that you have a place to spread out your notes and write without distractions.

You might be dreading this point. After all, writing is not always an easy process. My friend Maria enters into a deep depression when confronted with a writing assignment. This might sound extreme to you, but feelings of dread and anxiety often accompany the beginning of writing. It is equally true, however, that they will recede once you start. For this reason, I urge you to begin as soon as possible. Generally, the actual act of writing is nowhere near as unpleasant as the anticipation of it. I think of it as I would think of completing a crossword puzzle—work at it calmly until all the right words fall into place. So grab a snack (never work on an empty stomach!), find a comfortable spot to sit and work, spread your notes and images in front of you, and keep reading. And take heart: you are done with the hardest part—you have accumulated all the notes you will need and have given careful thought to your work. Composing the paper is now just a matter of organizing and presenting the information that you already possess.

The Introduction

Step 1: Write a Short Description of the Work You Have Chosen. The first section will serve to introduce your reader to the work of art. It should not be detailed, nor more than one or two sentences. It should describe the work in plain and simple terms, mentioning subject matter, medium, scale, and location. For example:

> *Menkaure and his Wife* is an Egyptian sculpture about four feet tall, made of slate, and located in the Museum of Fine Arts in Boston. The royal couple stand together facing outward, and the queen wraps her arm around her husband's waist.

While it might seem like an obvious beginning, I can't tell you how many papers I have received that begin with a discussion of Menkaure's elbows! It helps here to remember the process of seeing itself. When you first see an object, do you immediately hone in on its details? Typically, no. So remember, when you write, *always to proceed from general to increasingly detailed observations.*

Step 2: State Your Main Argument. Your second step will be to express the main theme of your paper. What should it be? Think back to the first moment you encountered your work. Remember the feeling or thought that came to you? Was it fear, mystery, romantic love? Put your statement in objective terms, and avoid the word *I*. It might go something like this:

> The sculpture evokes a sense of permanence and unity, . . .

This is the first part of your thesis statement. You are arguing, in your paper, that permanence and timelessness are the ideas that this sculpture evokes.

Step 3: State (Briefly) the Ways in Which You Will Prove It. These themes, you should now realize, did not simply appear in your head at random. Choices in the subject matter and formal elements such as line, composition, color, and style helped to create it. The main goal of your paper will be to describe *how this idea or feeling, so central to your response to the work, was created by artistic choices.* So, despite the innocuous name of "response" or "description" paper, this is really meant to be an *argument—your argument,* for why the work is so powerful. This does *not* mean you should second-guess the intentions of the artist. What

he or she meant by the work is less important, for the purposes of this paper, than the effect the work has on you.

So the second part of your thesis statement might read:

> . . . and this is evoked through the materials used, the composition, the relationship and poses of the figures, and the style.

Writing the Main Body

Step 1: Sketching an Outline. Having established your main argument, and the ways in which you will prove it, you may now proceed to the paper's main body. Here, you will detail the evidence for your argument, focusing on the elements you cited in your thesis statement. At this point you might be asking yourself, "Which element should I discuss first?" In general, it is advisable to *build up to your strongest points*. Think about what most strongly contributed to the work's overall effect on you. End with that. In the case of a paper on *Menkaure and his Wife* (fig. 29), you might want to begin with a discussion of materials and conclude with a section on the poses of the figures.

In the case of the main body, it might be useful to sketch a quick outline before beginning to write. Give each of your sections a heading such as "pose" or "figural type." Then, after each heading, provide a description of that element in your work. Be as detailed and vivid as possible. Consider again the example of the paper on *Menkaure and his Wife* (fig. 29). An outline of its main body would look like this:

```
II.  Main Body

     A.  materials

         1. slate
         2. greyish black stone
         3. looks hard and smooth
         4. gives sense of unchangingness, stillness

     B.  composition

         1. the two forms are physically attached to each
            other
         2. little space between them
         3. seem to form a single, stable mass
         4. this also gives a sense of unity and stability
```

C. Facial Expressions

 1. the expressions of the couple seem blank
 2. mouths are closed and still
 3. this adds to the sense of unchangingness

D. Treatment of the Figures

 1. Figure type

 a. they seem youthful
 b. he has broad shoulders and a narrow waist
 c. she has a very slim, soft-looking body
 d. she is covered with a transparent garment
 that emphasizes her body

 2. Pose

 a. they seem stiff and erect
 b. no twisting or shifting of weight
 c. these qualities also gives a sense of
 stillness and timelessness

Note how the sections above were organized in terms of art-historical elements (materials, composition, facial expressions, and treatment of the figures). Then came a description of how the work in question used those elements. In the case of *Menkaure and his Wife,* the composition consists of two forms that are attached to each other. Finally, the sections end with a statement of how each element *contributes to the overall effect.* This is a restatement of your main thesis. Hence, in the example given, the figural pose of the Egyptian sculpture lends to its sense of timelessness. Do the same for the work you are writing about, going from category to category, and listing your points in outline form.

Step 2: Writing the Paragraphs. The above outline is rather abbreviated— you may very well have more descriptive details in your paragraphs. The more, the better. But it is also important to keep them ordered. Remember, each section of your outline should constitute a new paragraph. Moreover, as you start each new paragraph, *begin with your most general observation, and then list the details that support that observation.* Be as minute and painstaking as possible; remember, your job is to persuade the reader of your argument. At the end of each paragraph, tell the reader how those details support your main argument. Here is a sample paragraph from the main body of our paper on *Menkaure and his Wife* (fig. 29). (I have added annotations in bold to show you the paragraph's structure.)

```
(Subject heading: the pose of the figures): We get a
sense of permanence from the way the figures are
posed. They are not leaning over or in a casual
pose. (General observation): In fact, they seem to
be as stiff and rigid as boards. (Detail 1): The king
has broad shoulders and does not slump at all; he
holds them completely erect and straight. (Detail 2):
His arms fall down to his sides and his hands are
clenched into fists. (Detail 3): His wife, although
smaller, also stands with broad, squared shoulders,
and her neck and head are very erect. (Detail 4):
Both stand without turning to one side, but are com-
pletely frontal. We also get a sense of permanence
and unity from the positioning of the figures' legs
and feet. Although they both appear to be striding
forward, we really don't get the sense of motion.
(Detail 5): Menkaure and his wife's legs and feet
are not, as in a regular walking stride, more
weighted on one side than the other; rather both the
right and left sides are perfectly balanced.
(Concluding statement: *How* the details support the
main argument): For these reasons, the figures'
poses give the impression that they are almost like
geometric forms: solid and unchanging, and in this
way, convey a sense of stillness and permanence.
```

Note how the writer has gone from making a general observation—the figures "seem to be as stiff and rigid as boards"—to citing specific examples of *how* they look stiff and rigid (erect shoulders, straight arms, clenched fists). Then, she has told us how this stiffness contributes to her main impression of the work ("they are almost like geometric forms: solid and unchanging . . .").

Having written up paragraphs for each important element of the work, you have now completed the main body of your paper. But let's say you have made other observations about the work that you would like to include, but which don't necessarily fit into your argument. If you feel they are important, you should include them, perhaps in a final paragraph before the conclusion. In the case of the paper on *Menkaure and his Wife,* you might also want to talk about how the two figures also convey ideas of unity. Whatever it might be, including such observations in a separate paragraph shows your professor that you have considered the work thoroughly, and also that you don't wish to interrupt the flow of your main argument. She will also appreciate your sense of organization.

Step 3: Writing the Conclusion. End your paper with a conclusion that reiterates your thesis statement, repeating both the particular message the

work conveys and the ways in which it is conveyed. This is sufficient. However, if you wish to go farther (and impress your professor even further), think, for a moment, about how the work relates to a larger issue. Let's take the example of *Menkaure and his Wife* (fig. 29) again. You have persuaded your reader that the work communicates the idea of permanence. Now you can afford to make a few speculations about why this idea seems to be so important in the work. You could make, for example, the following generalization:

> *Menkaure and his Wife* shows how the artistic choices in materials, composition, form, and so forth, can communicate a profound idea—perhaps that the idea of harmony and permanence were important in ancient Egypt. If we look, for example, to the pyramids, we also see a sense of wanting to preserve the past, to perpetuate the memory of powerful rulers. *Menkaure and his Wife* seems to belong to that way of thinking.

Some Further Tips on Writing

1. Be as detailed as possible. Your professor will appreciate it if you go into detail to support your observations.

2. But keep your details organized! Too often students will simply write up a muddle of interesting observations. Make sure to put them in a sequence. I often tell students to pretend they are describing the work to a blind person. Would you start by discussing an elbow?

3. Make an outline. This will spare you from producing one of the worst kinds of student papers I know—one that incites disappointment and displeasure in every professor: the one-paragraph paper. I am not referring here to length (although a paper less than the desirable number of pages is never a good idea); rather, I am referring to a three-page paper with no paragraph breaks. *Never do this.* It shows that you have no internal structure for your paper, and suggests that your ideas are muddled. Again, using an outline will solve this problem.

4. Forget that you are writing for a professor. I find that many of my students leave out important statements (for example, "this is a portrait of a man and wife" in the sculpture of *Menkaure and his Wife*). When asked why, they reply, "You are the professor—you already know all that!" Write as if your professor were just another student. This paper is your chance to be the teacher. Help your professor see the work as you see it.

5. Don't worry about flowery writing. Students will often try to impress their teacher with vocabulary they cannot control. Do not do this. It only frustrates your professor and makes your writing appear pretentious.

6. Terms to avoid: "artwork" and "piece."

7. Number your pages. Lack of pagination is an annoying but common error. If your paper is too short (or too long), omitting page numbers may be construed as an attempt to pull the wool over your professor's eyes.

8. Provide an illustration. If at all possible, include an image of the work and/or your own thumbnail sketch at the end of the paper.

9. Always proofread. It helps to read the paper aloud. This will highlight grammatical errors or awkwardness that would otherwise go unnoticed. For further guidance on issues of grammar and style, see Sylvan Barnet's *A Short Guide to Writing About Art* (pp. 123–128: "Some Conventions of Usage") and Henry Sayre's *Writing About Art* (Appendix, pp. 124–137: "A Short Guide to Usage and Style").

10. Have a friend read it. This is even better than reading it aloud yourself.

4

The Art History Exam

The horror of the slide exam: the lights go down and the slides go up on the screen, with no professor to explain them. One minute per identification . . . ten minutes per comparison . . . The slides change, but you aren't done writing . . . WAKE UP! If you are already having nightmares about the upcoming exam, read on. This chapter will prepare you for the typical art history exam, guiding you through its different components: slide identifications, comparisons, essays, and unknowns (to name a few). It will also teach you to organize and prioritize your notes for study, suggest study aids for remembering images, and offer helpful hints for the process of taking slide exams.

You might be asking yourself, "Why bother with a chapter on how to take an exam?" After all, you have taken them before. How can art history exams be different from any others? If you come to the lectures, take notes, study, and do the reading, you will do well on the test, right? Maybe yes and maybe no. Art history exams are unique. First of all, they are primarily visual. Instead of focusing all your attention on a page of written questions, you will be asked to respond to a series of slides requiring identification, comparison, and analysis. Think about it: your study notes, concepts from the readings, the facts you need to memorize—all these will need to be recalled through images. There is another important

difference: if you are taking a test in math or English, you are generally allowed to complete different sections at your own pace and in the order you prefer. This is not possible with an art history exam. Each slide will go up on the screen for a set period of time, within which you must write your answer. (Of course you can always return to complete your answer, but not with the benefit of the slide.)

So, if you haven't taken such an exam before, you will find that this format demands a different type of studying and a different type of test-taking. It involves thinking on your feet and being able to deal with the pressure of a timed exam. To get an A, then, you must not only have a good understanding of the material, but also understand how to study for and take the exam itself. In this chapter, you will gain that knowledge. And in the process of unveiling the mysteries of the art history exam, you will be relieved of a good deal of your exam-related anxiety—a condition which often leads to muddled thinking and ultimately poor test performance.

THE BASIC PARTS OF AN ART HISTORY EXAM

Proviso. *Because art history exams vary from professor to professor, it is essential that you ask your professor about his or her test format before even beginning this chapter.* However, almost all art history exams include a few key components that we will deal with in turn. You may find, after consulting with your professor, that your particular exam focuses more on one component than another; obviously, then, you should pay more attention to it. In any case, knowing the format of the test is crucial to good studying. Knowing facts is not enough; you need to know how to recall them, and in what manner you will be asked to provide them.

The basic parts of the art history exam are as follows:

Identifications. *Identifications* are slides which appear on the screen only for a short time (often just a minute each) and which require you to provide the name, date, and period of the work shown. In other words, the slide will pop up on the screen, and you will write down the necessary information about it. Sometimes, however, the professor will also require you to write a few sentences about the significance of the slide. In such cases, you will generally have more than a minute to write your answer.

Slide Comparisons. These are more involved and usually take the form of an essay. Two slides will appear on the screen, and you will be asked (1) to identify them and (2) to compare and contrast them. Sometimes your professor will give you a leading question to help focus your answers.

Essay. In addition, you might have to write an essay. Often this is the only portion of the exam not based on slides. Instead, you will be asked to discuss a certain theme or trace a development in art history, using works as examples. (For example, you might be supplied with a list of monuments from Old St. Peter's Basilica at the Vatican to Brunelleschi's Basilica di San Lorenzo in Florence, and asked to write an account of the development of church architecture.) The essay question usually comes at the end of the exam. Make sure to save your energy for it, however, because it often counts for the most points.

Unknowns. These are a favorite among some art history professors. In an "unknown," a slide will appear that you have never seen before in lectures or readings. You will be required to write down what you think it is, guessing its artist, date, period, and location—and then give specific reasons for your answers by linking it with works you have studied in class.

Other Components of an Art History Exam. Depending on your professor, and the nature of your course, your exam might also include such sections as matching works of art to artists, defining key terms in one or two sentences, or diagramming images or ground plans of architectural works. Some professors also give multiple choice essays. We will not focus on these elements, however, since in format they are already familiar to you from other courses.

Again, remember: *Your professor's wishes are the most important, and his or her instructions on how to study must always be honored first.*

Identifications

Your exam will probably begin with slide identifications. This is good, because your short-term memory (necessary for memorizing all those names and dates) will be at its freshest. Most likely, you will have a sequence of several slides to identify, ranging from five to ten. This will be the fastest-paced part of the exam, with each slide counting for one or two points.

Of all the portions of the art history exam, it is the slide identifications that strike the most fear into the hearts of students. I think it is because the experience is so dramatic—the slide goes up, and you either know it or you don't. Many students feel anxious about their ability to memorize images and their relevant information. We will get to that in a moment. First, let's go over precisely what a slide identification is.

Title. You will most certainly need to know the title of the work. Remember that the title might be descriptive, such as the *Crucifixion* or *Jar*

with *River Scene* or *Central Tympanum, Royal Portal, Chartres.* It might also be a title provided by the artist, such as Jackson Pollock's *Totem 3.* The more descriptive the title, generally, the easier to remember—an important consideration when it comes time to study.

Artist. You may also be asked the artist of the work. In many cases, and particularly with art produced before the Renaissance, we simply don't know the identity of the artist. In this case, obviously, you can ignore this question (or write down "Anonymous"). For artists active in the Renaissance, sometimes only first names are used, such as Leonardo (for Leonardo da Vinci). For later artists, generally the last name will suffice (for example, Stella instead of Frank Stella). It is usually unnecessary to remember both first *and* last names. (However, there are exceptions: if you happen to be taking a course on Venetian art, you will certainly want to be able to distinguish between the three Bellini brothers: Jacopo, Gentile, and Giovanni!)

Location. Depending on the work of art, you may also be asked its specific location or site. In the case of architecture, knowing location is crucial. You must know, for example, that the pyramids are in Giza, Egypt, and that the Robie House is in Hyde Park, Illinois. In the case of painting, it is often up to the professor. Generally, if a work still stands in its original location (often the case with fresco painting), you will be asked to know it. So, for example, you should know that Masaccio's *Trinity* (fig. 17) is in the Church of Santa Maria Novella in Florence. If the work has been relocated to a museum, you probably won't be required to know its location, but make sure to consult with your professor about this.

Date. Dates are more tricky and variable. When giving an exam, I am often asked about the "margin of error": "If my answer is within fifty years, will it still be counted as correct?" This is very difficult to generalize about, because information on dating varies so much from period to period. While we know that the contemporary painter Anselm Kiefer, for example, painted *March Heath* in 1984, we can only date prehistoric works like the *Woman from Willendorf* (fig. 16) to a very broad time frame, c. 22000 B.C. There are other variables as well. In the case of Egyptian or Asian art, you might also be asked for the dynasty in which the work was created in addition to its date. On the other hand, in the case of classical sculpture, you will often be looking at a Roman *copy* of a Greek original. Which date should you remember—that of the Greek or the Roman work? In general, you will be asked the date of the original. However, always remember that *the guidelines for knowing dates will be*

set by your individual professor, and he or she is the one to consult on this. And make sure to ask what the margin of error is. Five years? Fifty years? This will help you when it comes time to study.

Period or Movement. This information is often asked as a separate category. Here you will want to be precise. Is it Renaissance? Rococo? Post-Impressionist? Try to be as specific as possible. If you are tested on the *Nike of Samothrace* (fig. 8), for example, don't just write down that it is "Greek," but specify further that it is "Hellenistic." Your professor will give you guidelines about this, but if he or she doesn't, make sure to ask.

Medium and Materials. In some cases, you might also be asked for the *medium* of a work. Is it architecture? An engraving? A collage? An oil painting? An earthwork? You might also be asked to describe the material the work is made of. Is it basalt? Is it reinforced concrete? Is it glass? Before you start to study, ask your professor if you will need to know medium and materials.

Studying for the Slide Identifications. First, the horrible truth: the only way to prepare for slide identifications is to memorize the images and facts you need to know. This is not easy, particularly if you are responsible for a lot of images. However, preparing the *right* way will cut down on wasted time and energy. Here are some tips:

1. First, make copies of all the images you need to know. Either make photocopies or, if your professor has set up a website with the images available, print them out from the computer. As long as the image quality is good, either route is more effective than studying the images from the textbook, because you will be able to shuffle them into a random sequence and study them as you would any flashcards.

2. Write the name, date, period, and location on the back of each image. This is relatively rote work, and might seem to you like a waste of time. You might be asking yourself, "Why can't I just look in the book, or on the website, where both the images and their relevant facts are stored?" Now, I am not advocating ignoring your textbook or course website. But something about the mechanical process of writing down the facts pertaining to an image lodges the information in your memory. For this reason, it is best not to have many distractions while you are doing this, so try to work alone. If you must listen to music, listen to classical music with no vocals. For some reason, instrumental classical music seems to help with concentration and memorization.

3. Go through each of the images and test yourself on what you know. You might find that you can easily remember certain aspects of works of art while other features just won't stick. For example, while you might be able to

recall names, you have may terrible trouble with dates. This is quite normal, as dates do not, implicitly, have anything about them that relate to the images. This is why I advocate using memory (mnemonic) devices. How does this work? Let's say you need to remember a still life that was painted in 1839. Scan the work for something you can relate to the number. Perhaps the painting features a bottle of wine. Note that "nine" and "wine" rhyme. To further embed the date in your mind, repeat, in a loud voice, "1839, 1839, 1839," as you look at the image (and particularly at the bottle of wine). This might seem a somewhat silly way to study, and this is another reason to work alone! Nevertheless, silly and surprising ideas are often easier to remember, not to mention more entertaining. The most effective method is to make up your own devices, but here are a few of my favorites, provided by my students:

Image: Botticelli's *Adoration of the Magi,* 1477

> "7–7—it was a very lucky day, with the birth of Christ and the visit of the Magi!"

Image: *Page with Mark the Evangelist, Ebbo Gospels,* c. 816–840 (fig. 21)

> "The evangelist with his wrinkly gown has clearly pulled an all-nighter, and is still up at 8:20 A.M.!"

If you are stuck on a particular image and can't think up a good mnemonic device, practice saying the date over and over again while you look at the image. This will help to internalize it, and in the process, you will likely find a way to remember it.

4. Drill yourself. Now, take all of the images and go through them one by one. You will find, most likely, that just by writing down facts on the back of the image, you have already, with no effort, committed some of them to memory. As you go through the images the first time, ask yourself out loud the name, date, and artist. Do this two or three times. When you find that you can remember certain images very well, put them aside in a pile and keep working on the difficult ones. Drill yourself over and over until you have no images left in your first pile. Then, take all of the images, shuffle them, and go through them again. This time, *write down* the answers on a separate piece of paper. This might seem repetitive, but by writing the information down, you will be simulating the process of taking the test. Also, by both by *writing* the answers and *voicing them aloud,* you are embedding the information in your memory in two different ways. It is best to start this process at least a week before the exam, when you are not in a panic. Keep the cards close at hand, so that you can go through them when you are waiting at the dentist's office, watching TV, or sitting on the bus. Take four or five images with you every day to school and quiz yourself on them. After a while, the information will stick. Moreover, starting the process with this kind of "easy" studying will help to alleviate some of your stress.

5. Draw up a timeline. Now that you have time periods and their approximate dates written down for each work of art, make up a timeline. To do this,

attach several sheets of notebook paper and draw a timeline across the top of it. Then, from left to right, write down each period name along with its specific time frames. Below each period name, form columns listing all the works of art that belong to it. This is not only a great study tool, but the process of creating the timeline itself will help you to organize mentally the works of art by their periods and dates, and this information will also be embeded in your visual memory. And remembered, if you are confused about terms used in dating works, such as B.C. and A.D., consult "A Quick and Easy Guide to Chronology" in Chapter Two.

An Emergency Solution for Procrastinators. At this point, you might be horrified. Perhaps your test is tomorrow. How can you possibly complete all this memorization in a few hours? If you are ready to give up from the stress of it all, you might try the following solution: rather than remembering dates for each work of art, *group them by period and learn only the date of the period.* This will cut down significantly on the amount of data you need to remember. And even if they do not, technically, accept approximate dates, most professors will give you partial credit for your answer.

How to do this? First, go through your images and group them according to their period. For example, let's say your test will cover ancient to medieval art; you should commit to memory each period within that era and its time frame. So, your study notes might look like this:

Prehistoric art: 22–16000 B.C.

Egyptian art: 3100–1285 B.C.

Ancient Near Eastern art: c.3100–460 B.C.

Minoan and Mycenaean art: 21500–1100 B.C.

Archaic Greek art: 600–450 B.C.

Classical Greek art: 450–400 B.C.

Third Century and Hellenistic art: 300–150 B.C.

Roman art: 100 B.C.–300 A.D.

Early Christian and Byzantine art: 300–750 A.D.

Early Medieval art: c.750–1100 A.D.

Gothic art: 1150–1400 A.D.

It is important to note that the above list is extremely condensed. For example, I have collapsed the separate periods of Roman art (Republican, Early Imperial, Late Imperial) into a single category. Early medieval art, likewise, could have been separated into Carolingian, Ottonian, and Romanesque art. Certainly, the number of periods you wish to study depends on the requirements of your professor and how much time you

have. Finally, if your professor has not provided you with period time frames, you can construct them yourself: simply choose one period and note down the earliest and the most recent work belonging to it—this will provide you with beginning and ending dates.

EXAM TIME

Having considered *how to study* for the slide identifications, let's address the problem of how to deal with them during the exam. Here are some tips for success:

1. **Read the instructions.** Make sure to provide *all* the information requested: name, date, period, and location (if architecture). Too often students will lose points because they simply forgot to complete the identification, even though they knew the answers!

2. **If you blank out, guess.** As long as you write something down, you might get partial credit. An empty page means zero points.

3. **Follow your first instincts.** This is tried and true. I can't tell you how many exams I have graded in which the student has crossed out the right answer only to put the wrong one in its place! First instincts, for whatever reason, are usually right.

4. **Watch your time.** As soon as you know the answer, write it down immediately. You don't want to be rushed or flustered when getting to the next question. Remember: in a timed exam, minutes are points.

5. **Get to class early!** If you are late, you lose points. Very few professors will go back through the exam for latecomers, no matter what the excuse.

Short-Answer Identifications

After making the identification, some professors will ask you to write a few lines about the work. This is often referred to as a "short-answer identification." In some cases you will be asked a specific question about the *style* or *content* of the work, or its *historical* **context.** In other cases, you might be able to choose what you would like to comment on. Either way, this part of the exam requires more preparation than regular identifications. You must go from simply memorizing names and dates to internalizing concepts and themes.

Studying for the Short-Answer Identifications. By preparing flashcards of your images for the regular identifications, you are already half way there. Now, on the back of each flashcard, write down three key

elements (words or phrases) that make the work important. These should relate to themes and concepts from the lectures and the readings. Go through the flashcards again and memorize those ideas.

You should also group the images in terms of the period to which they belong, and then focus on the elements that distinguish that period. The art of Egypt, for example, often conveys ideas of permanence and an interest in the afterlife. Again, go through your lecture notes and readings and locate a few key ideas that distinguish each period. Note down not only the generalizations drawn about the art of the era, but also—and this is important if you want to get an A—any other trends that might have had an effect on the arts. The rise of humanism, for example, had an important influence on Renaissance art, and Impressionist art was created during and in response to the Industrial Revolution of the nineteenth century. These generalizations, both about art and about the world in which it was produced, are your *macrostatements,* broad statements about the period as a whole, and they are useful not only for slide identifications, but also for slide comparisons, essays, and unknowns.

Now that you have internalized a few key ideas for each image, you need to learn how to recall and express them during the exam. The way you communicate your ideas is important here. Be *specific* and *substantive.* For example, let's say that the *Return of the Hunters* (1565) (fig. 19) by Pieter Brueghel the Elder pops up on the screen. After filling in the identification information, you must now write a few lines about its significance. You might choose to write about its **form:**

> `Example:` The panoramic view is typical of the artist. One can see several groups of figures, from the large hunters in the foreground to tiny skaters in the distance. Also important is the composition, in which the strong diagonals of the mountains are interrupted by the vertical line of trees.

Note here that the answer is composed of specific points. The student has not just praised or described the work, but has provided a series of concrete facts about it as well.

Now, let's say you choose to comment on the *content* of the work. Here are two answers, one strong and one weak.

> `Weak:` This painting depicts a scene of life in the country during the winter.

This is not enough. It does not reveal that you know anything more than you could have known simply by looking at the image. It is not *substantive* and it is not *specific.*

> **Strong:** This scene is typical of the work of Brueghel, who was interested in the activities of peasant country life as much as in religious subjects. In the foreground, he depicts hunters with their dogs and a group working around a fire. Brueghel was also interested in showing the different seasons; here we get a real sense of winter through his depiction of snow-covered mountains and frozen ponds in the distance. The inclusion of minute details and interest in scenes of daily life is typical of Renaissance art of Northern Europe in the sixteenth century.

Note how the writer of the second example has made a series of concrete observations about the work (the hunters, the frozen ponds, the snow-covered mountains) and discussed how they were typical of Brueghel's art. In addition, she discussed how these elements are typical of the period and region as a whole. Try to do this whenever possible. It shows the professor that you can do more than just discuss the work itself; you can also relate it to the broader trends that it reflects.

Here, then, are some tips on doing well on short-answer identifications:

1. Choose one element of the work, such as style or iconography, and make it your focus. This way you will have time to be sufficiently specific.
2. Relate your observations about the work to ideas and themes typical of the period.
3. Unless instructed otherwise, don't just list words or phrases—this shows no effort on your part. Develop at least three clear sentences for your answer.

Slide Comparisons

Slide comparisons are the mainstay of an art history exam. If you have been going to class, you already have a good idea of how they work, as your professor has used them in lectures. Why do we do this? Because while we can talk until we are blue in the face about what is new or different about a work of art, there is nothing like a well-chosen comparison to illustrate our point. We might show comparisons to highlight developments in handling the figure, composition, or color. We might simply want to show how the same subject, such as a portrait of musicians, can be handled very differently, depending upon whether we are looking at a

Caravaggio or a Picasso. Comparisons highlight change, and this is what we want you to see. The two images might be from different time periods, or created in different geographical regions, or by different artists. Your task is to consider each work closely and critically, and identify the changes that the pair highlights. This will involve careful thinking and writing, and, as with the short-answer identifications, a combination of specific observations and broad statements.

In terms of length and structure, slide comparisons on exams vary. They might run anywhere from five to twelve minutes (or longer). Your professor might provide you with a leading question to help focus your essay. Otherwise, you are on your own. For the purposes of this book, let's take the more challenging route—let's say you must construct the comparison essay yourself, without a leading question.

As mentioned previously, your professor will not choose two random slides and ask you to compare them. He will show you a pair that illustrates an important point. To give you a sense of how this works, I have provided below a series of possible slide pairs from ancient to modern art with guidance on how to compare them. Review them carefully; not only will they give you a sense of how to approach this part of the exam, but these specific pairs are actually chosen very frequently by professors!

1. *Khafre* **(fig. 14) vs.** *Augustus of Primaporta* **(fig. 5) (Egyptian vs. Roman art).** These works share some very basic similarities: both are freestanding sculptures and portraits of rulers. Both, also, communicate the power of the person represented. Note that each of the figures wears the attributes of rule: the *Khafre* with his customary headdress and kilt, and Augustus with his armor displaying scenes of military triumph.

The way the figures are conceived and posed, however, present dramatic differences. For example, *Khafre* sits erect and somewhat rigidly, with his entire body perfectly frontal in pose. He is as still and geometric as the chair in which he sits. *Khafre* seems removed from our world, and conveys a sense of divinity that is typical of ancient Egypt, in which rulers were worshipped as gods. *Augustus of Primaporta,* on the other hand, stands in the naturalistic *contrapposto* of the classical era. His bent left leg, slightly turned torso, and raised right arm create a sense of believable movement.

What is the point of the above comparison? First, to lead you to consider how they are similar: both are rulers, both deal with the theme of political power. Second, it is to lead you to see how two works of the same general subject can differ dramatically. It is your job to enumerate the ways in which they differ and what makes each typical of its period.

2. **The sculpted tympanum by Gislibertus of the *Last Judgement* from the Church of Autun, Saint-Lazare (fig. 10) vs. the central tympanum, west facade, of the Royal Portal at the Cathedral of Notre-Dame, Chartres (fig. 9) (Romanesque vs. Gothic art).** At first glance, these two works seem quite similar. They are both examples of relief sculpture, and both decorate the portal of a church. Both belong to the medieval period. However, they illustrate an important development from Romanesque to Gothic art. At Autun, an enthroned Christ dominates the image: the space around him is filled with dramatic scenes from the Last Judgment—the resurrection of the dead, the weighing of the souls, the saved going to heaven, the damned going to hell—all this is contained on the flat surfaces of the stone. Christ, like the other figures, is elongated, and his *drapery,* swirling in linear patterns around his long limbs, adds to the drama of the image.

By contrast, the Chartres portal is spare and calm. Here, too, Christ sits enthroned, but now he is carved in much higher relief, creating a real sense of *volume*—of stone projecting out from the wall plane behind. The depiction of Christ has also changed; the elongated, expressionistic form at Autun has been replaced by a naturalistically proportioned figure. He is not surrounded by scenes from the Last Judgment but by the four symbolic beasts of the *evangelists.* Unlike at Autun, moreover, these surrounding forms are not packed together. Rather, empty spaces separate each of them, allowing for a much greater sense of readability.

The point of this comparison? First, for you to see that both are typical works of the Middle Ages: sculpted church portals depicting Christ. Second, for you to see a shift from Romanesque linearity and *expressionism* to the new Gothic sense of organization, clarity, and *naturalism.*

3. **Pierre-Auguste Renoir, *Bathers* (1887) (fig. 12) vs. Pablo Picasso *Les Demoiselles d'Avignon* (1907) (fig. 13) (Impressionism vs. modern art).** Both of these works depict a group of female nudes. In Renoir's painting, the three women represent *ideal* beauty. As they play and cavort by the riverbank, they seem designed to arouse the viewer: for example, the central woman rubs a towel along her back, a gesture that serves to frame and highlight her nudity. The figures are bathed in gentle colors and modeling, suggesting round bodies and soft, youthful skin. Renoir's style of representation, moreover, is *naturalistic;* the figures and the details of the setting are included and recorded with relatively precise detail. The pastel colors, soft *modeling,* and *painterly* style are typical of Impressionist art.

Although Picasso's work features the same subject matter, it has been interpreted in a very different way. The artist has transformed the figures from idealized nudes to angular, inelegant forms, defined not by soft modeling but by harsh outlines. In place of the smiling, playful Renoir bathers, Picasso presents us with grim-faced women who confront us with raised arms in a gesture of frank

sexuality. In this way, the artist has abandoned the typical representation of the female nude as an object of male arousal and created instead an image that seems aggressive and almost primeval.

The point of this comparison? To show how differently the same subject matter can be handled. The pair illustrates the contrast between the idealized female beauty typical of the Impressionist era and the *abstract* and almost aggressive portrayal of females in the modern age.

Organizing the Comparison. Now that you have a sense of the content of a good comparison, let's attack the problem of how to write it. As with slide identifications, it is crucial to have a system of organization. In the section below, I have outlined the sequence of steps to take.

Step 1: State the Obvious. Notice how in each of the above comparisons, I have stressed the importance of stating the *obvious ways* in which the works are similar. Students often forget to do this. Why? Because they know that the person grading the exam *already knows the obvious*. And we do! But we still want you do begin with it. As a rule, pretend you are writing for someone who is intelligent but has no previous knowledge of art history. So for example, with the comparison of Autun and Chartres, start out by stating that both are medieval church portals, both are relief sculptures, and both depict Christ. Then, and only then, move on to the differences between them. So the first part of your essay should look like this:

AUTUN VS. CHARTRES PORTALS

I. Similarities

 A. Both are medieval
 B. Both are church portals
 C. Both are **relief** sculptures
 D. Both depict Christ

Step 2: State the Nature of the Comparison. Now that you have established the basic similarities of the two works, you should consider the nature of their relationship. Was one produced earlier than the other? In another geographical area? Were both produced by the same artist but at different periods of his life? *This statement is very important because it tells the professor you understand the point of the comparison.* So the

second part of your essay should look like this:

AUTUN VS. CHARTRES PORTALS

II. Nature of Comparison

 A. Autun was produced in the Romanesque period
(c. eleventh century)

 B. Chartres was produced in the Gothic age
(c. thirteen century)

 C. The comparison shows the *development* of medieval
sculpture

Step 3: Enumerate the Differences. Next, enumerate the differences between the two works. This is the most complex task, because typically the two works will be distinguished by several elements. To manage the volume of information, organize your comparison into categories such as form and content. So the third section of your comparison should look like this:

AUTUN VS. CHARTRES PORTALS

III. Differences

 A. Form

 1. Organization

 a. Autun: cluttered
 b. Chartres: clear

 2. Volume and space

 a. Autun: flat, linear
 b. Chartres: much more projecting of forms; more
relief

 3. Treatment of the figure

 a. Autun: elongated, angular
 b. Chartres: naturalistic

 B. Content:

 1. Autun shows the Last Judgment
 2. Chartres features Christ and Four Evangelists

Step 4: Create Your Macrostatement. You have now finished the hard part: differentiating between two works. Now you have only one final task to face: you must *move beyond* the immediate slide comparisons and

turn to the macrostatements. First, what makes each work typical of its period? Start by making a macrostatement about form: for example, the flat, linear style of the portal at Autun is typical of the Romanesque. Use the word *typical*. It will show your professor that you understand more than just the works on the screen—you understand how they fit into a broader art movement.

Now that you have stated what is typical in terms of form, place the works in their broader historical context using macrostatements. For example, with its elaborate Last Judgment scene, the Autun portal was produced at the turn of the first millennium, a time of great anxiety about the coming of the end of the world. You could point out that the flat, elongated figures, with their nervous linearity, express this feeling in visual terms. The portal at Chartres, however, was produced in the thirteenth century, an era which witnessed the rise of intellectual inquiry in France, and particularly a new interest in the physical universe. The naturalism of the figures at Chartres may be viewed as a reflection of this movement. *Notice how these statements show that you know more than just the works themselves—you know how they relate to the world in which they were produced.* So the fourth and final section of your essay should be organized like this:

AUTUN VS. CHARTRES PORTALS

IV. Generalizations on Form and Context

 A. Autun

 1. Form: flat, linear style, long figures typical of Romanesque art

 2. Context: nervous quality of forms reflect anxiety about end of world

 B. Chartres

 1. Form: sense of volume, spatial clarity, naturalistic figures typical of Gothic art

 2. Context: naturalism and clarity reflect new rise of learning in thirteenth century France

At this point, you may be asking yourself, "Will I be able to remember all this when I get into the exam?" This is certainly a valid concern. You can't expect to know everything about every slide. But the key to success in slide comparisons is not just having a lot of memorized knowledge; it is about having a systematic approach. If you use the system laid out here, you will not only be able to complete the comparison more

thoroughly, but you will also be less likely to panic (always a deterrent to recalling information). Below is a checklist of questions to ask yourself. It is not likely you will be able to bring it into the exam, but try studying with it—the more you internalize it, the better you will structure your essays.

1. **How are these two works similar?**

> Form
> Content
> Same artist
> Same period
> Same medium

2. **Which was produced first?**

> left slide
> right slide

3. **How are they different?**

> Medium and materials
> Form (here you want to go into detail)

>> composition
>> space and volume
>> figure
>> style

> Content

4. **What makes each one typical of its period?**
5. **How does each work reflect the world in which it was produced?**

Tips on Writing the Slide Comparison. Unlike slide identifications, comparisons require you not only to know facts, but to organize and communicate them clearly. This is not so easy during a timed exam. It *is* easy, however, to panic, and this is often evident in the kinds of student essays I have read. Below are twelve tips on performing well under pressure:

1. Identify both works before beginning. Write down the vital statistics of the works in left and right columns before beginning. Too often, in the rush to get started, students forget to do this. Although you might go on to identify the works in the body of the essay, your grader might not notice. It is easy to lose points this way, so make a point of remembering to identify the works at the beginning.

2. Draw an outline. The previous outline was presented for the purposes of showing you how to structure your essay. However, time will not permit you

to compose such a detailed outline on the exam itself. It will have to be much more schematic. However, even if it is just a few lines, make sure to sketch your outline *on the exam*. Not only will it help you to structure your essay, but if you don't manage to finish in time, your grader will be able to see where you were going and not mark you down as harshly.

3. Make description work for you. In the slide comparisons, you will spend some time describing each of the works. But remember, you have limited time; you can't describe each work in great detail. Instead, focus on describing the *elements of each work that allow you to compare them.* Let's say you are comparing Picasso's *Les Demoiselles d'Avignon* (1907) (fig. 13) and Fernand Léger's *Three Women* (1921). Both depict a group of nude women. Would you then focus on the black cat in Léger's painting that sits behind the group? (As intriguing as this beast might be, the answer is no).

4. Be specific. Always provide details. You must back up everything you say with specific observations and examples. If you are going to say that one work is abstract, you need to say why and how. If you think a figure appears "stiff," you need to make specific comments about body parts and posture. Being vague is a sure way to bring your grade down.

5. Write in complete sentences. Instead of writing an essay, students will sometimes list key words or phrases instead. *Do not do this.* Write out complete sentences with subjects, verbs, and objects.

6. Write in paragraphs. I am often faced with a comparison essay consisting of a single, disorganized paragraph. At this moment, I care little whether the ideas presented are good or not—I am already in a foul mood from the prospect of eyestrain. If you are confused about when to open a new paragraph, think in terms of key ideas. Are you switching from a discussion of one slide to another? From a discussion about the figure to one about space? Or from the exterior to the interior of a building? Any time you change the subject, change your paragraph! The body of the paragraph should contain observations and statements in support of the key idea.

7. Avoid "chicken scratch." Again, take pity on the person grading your exam. If it is your professor, he or she might be very ancient and suffer from severe eye problems—after reading thousands of books, journal articles, and, of course, exams like yours! Whoever your grader is, he or she will be annoyed by "chicken scratch," perhaps enough to mark you down for it. Don't take the chance. Write clearly!

8. Watch your language. Art-historical terms, when used correctly, will also earn you points. There are two special terms to use in comparisons: "anticipate" and "recall." Use "anticipate" when one work contains the seeds of the other, more recent work, as in the following sentence: "Suger's light-filled ambulatory at St.-Denis, a work of Early Gothic architecture, anticipates the High Gothic cathedrals of the thirteenth century." Use "recall" when a work refers back to an

earlier tradition, as in "Manet's *Olympia,* with its reclining nude, recalls Titian's *Venus of Urbino.*" These are wonderfully useful terms because they succinctly imply a relationship between the two works of art.

9. Refer to the works correctly. In the interest of saving time, many of my students will refer to works of art as "slide A" and "slide B" in the body of their essay, or "the one on the left" and "the one on the right." Professors generally prefer that you use an abbreviation for the work based on its title ("*Totem III*"), its artist ("the Titian"), or its location ("Bourges"—for Bourges Cathedral).

10. Write something, anything! Students often feel that if they don't have anything specific to say about the slides. They have blown the entire answer and leave it blank. *Don't!* Remember, slide comparisons are generally not graded as "right" or "wrong"—you will probably receive partial credit if you simply write something. And if you have been fairly conscientious, you will be surprised at how much can actually be said about a given work of art. Let's say you are faced with a comparison of two works that you can't remember. What should you do?

A. *Describe the two works, noting similarities and differences.* This will at least show your professor that you can look carefully at images. And the more art-historical terms you use in your description (when appropriate), the more points you will receive.

B. *Don't focus on what you don't know—use what you do know.* Perhaps your professor shows you a slide of an early Christian **basilica** (a longitudinal, aisled structure, usually with a curved termination, or **apse**) and you can't remember its name or date. However, you *were* paying attention in lecture when the professor discussed why the basilica was chosen as the official architecture of the Christian church. Use this knowledge! Including this kind of information will earn you points even if you can't identify the works.

Questions about architecture are particularly daunting on exams, since architecture can appear on your exam in so many different ways. Let's say you are confronted with the ground plan of a Greek temple. You know the work, but you really can't think of anything to say about the plan in particular. You spent all your time studying the elevation and decoration of the building. Have you blown it? No! There is no reason why you can't incorporate what you do know into the essay, or why you can't discuss aspects of the work that are not represented in the slide on the screen. In fact, doing so will show that you know more about the object than simply the slide put in front of you. This kind of resourcefulness will impress your grader.

11. Practice, practice, practice! One of the most difficult aspects of the art history exam is that each section is timed. If you tend to panic under pressure, you can easily lose your nerve and end up blowing the exam. This is the "choking" syndrome common to professional athletes. As in sports, however, there is one virtually foolproof solution to this problem: *practice*. Don't just study for the exam—*actually practice* working through comparison essays with the clock running. Pick out a couple of slide comparisons. If you can't decide on them, go through your lecture notes and find one that your professor has already used. Then set your watch and start writing. It doesn't matter if these same comparisons are not on the actual exam—it is a question of acclimatizing yourself to the test-taking process. Getting a little anxious, and working through that anxiety to actually complete a slide comparison will double your confidence about taking the test. And who knows, you might just have chosen a comparison that is on the exam!

12. If you run out of time. During the exam, try to stay aware of the time. Even if there is a clock in the exam room, bring your own watch so you don't have to look up and break your concentration. But let's say that you are running out of time on a comparison. Make sure that you have identified the slides so that you can return to the essay later if you have time. Even better is to make a little sketch of the slides before they are taken off the screen. Also, be aware that in evaluating your incomplete essay, the grader will scan your booklet for clues to the direction in which you were headed. This is why drawing up a quick outline on the exam booklet is so important—and it will probably earn you a few extra points.

The Essay Question

The essay question is a frequent component of an art history exam. Generally, it comes last and counts for the most points. Why are you given an essay? Because art history is not just about memorizing facts. While it is crucial for you to know key works of art, you must also understand how they relate to each other and represent a larger historical development. This requires you to pull together all the skills you have learned so far. You will need to consider works from several different periods and cultures, and how each addresses the same theme or problem in different ways. In some respects, then, the essay is the most challenging element of the art history exam. However, the essay also allows you complete freedom in the way you shape your discussion, allowing you to focus on the images and ideas you know best.

Students often have trouble studying for this part of the exam. Most spend much more time memorizing works of art than studying for the essay question. Yet it is crucial that you prepare for it, because while missing a slide identification might cost you a few points, blowing an entire essay will certainly cost you much, much more.

Types of Essays. There are several different types of art history essays, but it is likely that you will to be asked to write an essay about an artistic development, which requires you to discuss the relationships between different works of art. Here are some examples:

1. Discuss the representations of divine figures in the following works: *Khafre, Hermes and Dionysus,* and *Christ in Majesty* on the west portal of Chartres Cathedral. Considering style and iconography, describe how is each typical of the society that produced it. Why is an ancient Egyptian god represented differently from a classical Greek deity and a Gothic image of Christ?

2. The baroque style in Europe occurred concurrently with dramatic religious and political changes. Influenced by the ideas of the Counter-Reformation, artists were called upon to create dramatic works that could persuade viewers not to abandon the Catholic church in favor of Protestantism or to support a newly appointed leader. Using Bernini's *St. Theresa in Ecstasy,* Caravaggio's *Calling of St. Matthew,* and Rubens' *Henri IV Receiving the Portrait of Marie de Medici,* discuss the dramatic devices used by artists to stir the emotions of the viewing audience and persuade them to adopt a particular way of thinking.

3. The Abstract Expressionists concentrated on the surface of the canvas, rather than treating it as an illusionistic "window," as did previous artists. Describe how works such as Jackson Pollock's *Autumn Rhythm (Number 30),* Mark Rothko's *Homage to Matisse,* and Helen Frankenthaler's *Mountains and Sea* differ in their treatment of the picture plane.

Note how the above essay questions require you to have specific knowledge about a series of works of art, but also ask you to draw general conclusions about them as well. Rest assured, in studying for the slide identifications and comparisons, you have already procured the raw materials to do well on the essay. You know your individual works of art and the general characteristics that make each important and typical of its period. Here, however, you will be asked not only to comment on one work, nor compare just two, but *consider many works of art in relation to each other.* So the essay requires you to produce a combination of detailed and specific observations as well as a synthesis of broad ideas and concepts. This is a lot to handle, and sometimes the volume of information required can seem overwhelming.

Step 1: Draw an Outline. Here again, having a system will help you manage your time and organize your thoughts. As with the slide comparisons,

the first step in writing an essay is to draw up an outline. This outline should consist of the works of art you want to talk about, listed in the order in which you will discuss them. So let's say that you were given the following essay question:

> *Compare and contrast the concept of the figure in sculpture from ancient Egypt to the Renaissance.*

Here is a sample outline:

 I. Egyptian: *King Menkaure and his Wife, Queen Khamerernebty*
 II. Greek: *Doryphoros*
 III. Medieval: Christ on the *Last Judgment* portal, Autun
 IV. Renaissance: Michelangelo's *David*

Now, your outline does not have to be as neat or detailed as this. The main point is that you should write down the works of art you will bring into the essay and the sequence in which you will address them. This will provide you with the basic structure you need to begin writing.

Step 2: Write Down Your Thesis Statement. Often, after composing the outline, students will simply rush into a discussion of the first work of art. However, it is crucial that you start your essay with a thesis statement. For the above essay, the following thesis statement would work: "The conception of the figure changed dramatically from ancient Egypt to the Renaissance, in terms of poses, proportions, and human psychology." Note that the above statement is rather obvious: Of course change occurs! However, the second part of the sentence tells the reader where and how change occurred (in pose, proportions, and psychology). This way, you give your reader a general sense of where you are going with the essay, and the specific art-historical issues that you are going to focus on.

Step 3: Write the Essay's Main Body. As you begin the body of your essay, you will discuss each work in turn, beginning with a brief description focused on the elements you mentioned in your thesis statement:

> The sculpture of *Menkaure and his Wife* can be taken as an example from ancient Egypt. In this case, the married couple stand erect and frontal, their shoulders squared, arms rigid and fists clenched. Both seem to walk forward, but their weight is equally balanced on each foot.

```
Their bodies are very smooth and youthful. So, in Egypt-
ian figure sculpture we can see how the tradition seems
to be about rigidity, formality, and youth—perhaps a re-
flection of the importance of permanence and everlasting
life in that society.
```

When writing your essay question, it is crucial that you limit your discussion of individual works to points directly related to the main argument. Note how the essay above focuses on specific elements of the work that were introduced with the thesis statement about poses, proportions, and human psychology. The student did not discuss details of iconography or function—this would have diverged from the main point. Stick to your thesis statement—if you say you are going to compare color and composition in a set of paintings—make sure your descriptions focus on that. This seems obvious, but often students stray from their main point, leaving the reader confused and frustrated.

Also, note how the above passage described the figure and pose of the sculpture in detail. This is very important. Students often fail to write adequate descriptions. When asked about this, I often hear the following, "But you are the professor; you already know what the works look like." Of course I do—but that is not the point! An important skill you learn in art history is *how to describe,* and, as professors, we want evidence that you have learned that skill. So make sure to be explicit and vivid in your descriptions.

Make sure that you always use appropriate terminology. Not only will it make your essay more precise, but also it shows the professor that you have been paying attention. For example, if you are faced with a longitudinal, aisled church, it is more precise to say *basilica* rather than "church." When using these terms, it is very helpful to give the reader a brief explanation of what they mean. Don't just say that the *Doryphoros* uses **contrapposto;** explain that this term refers to a counterbalance of weight. Spell things out for your professor—not because you think she doesn't know, but so she will know that *you* know. Again, remember to pretend you are writing for an intelligent college student who has never taken art history. This way you will make sure to describe works of art and define your terms.

Step 4: Link Your Works. Let's say you are going to continue the essay with a discussion of a Greek sculpture. How do you relate it to *Menkaure and his Wife?* Consider the following passage:

```
The Greek sculpture of the Doryphoros shows many impor-
tant differences from the Egyptian statue. Instead
of the rigid, stiff pose of Menkaure and his Wife,
```

> the *Doryphoros* balances his weight naturally, using the
> classical pose known as *contrapposto*, in which the left
> and right sides of the body are counterbalanced. Here,
> instead of an emphasis on rigidity and formality, we get
> an increased sense of naturalism, typical of ancient
> Greek and Roman sculpture.

Note here how the student connected the Greek sculpture to the Egyptian work first discussed. It is crucial to link up your works of art this way. It is also particularly impressive if you mention how one work foreshadows a later one. For example, in your discussion of the *Doryphoros,* you can mention how classical *contrapposto* and *naturalistic* forms are revived in the Renaissance with Michelangelo's *David.* This gives the essay a sense of cohesiveness, and demonstrates your mastery not only of specific works of art but also of how they relate to each other. And remember: as you begin a discussion of each work of art, *start a new paragraph!*

Step 5: Restate Your Thesis. And after discussing each work, make sure to relate it back to your thesis statement. This is not as hard as it seems. For example, consider how the student treats the third work mentioned in his outline:

> Figure sculpture changed dramatically again in the Mid-
> dle Ages, as we can see with the sculpture of Christ at
> Autun. This is a relief sculpture, rather than free-
> standing (as in the *Doryphoros*), and it displays several
> important changes. First, the proportions of the figure
> are lengthened. The drapery falls over the body in lin-
> ear patterns—it doesn't look real. And the figure ap-
> pears to be moving in a strange, contorted way that is
> typical of medieval art.

Note how the paragraph began with a restatement of the main thesis— *that there is change in figure sculpture*—and then went on to outline how that change occurred.

Step 6: Write a Conclusion. It is crucial to conclude the essay instead of trailing off with your final example. The conclusion needn't be long; however, it should contain a final restatement of the thesis, as well as a summary of how the discussed works illustrate the thesis. End this section with a final *macrostatement* in which you ponder the larger issues that you raised in the essay. For the sample essay above on sculpture, you

might include the following:

> The changes in the figure that we see through time are
> related to the varying needs and beliefs of the soci-
> eties that produced them.

It might seem rather generic, but after reading so many detailed ob-
servations, your reader needs a "big picture" ending, and the above
macrostatement achieves just this. It also serves to wrap up the essay
neatly.

Often your professor will assign readings from journal articles in ad-
dition to your textbook chapters. Although textbooks tend to impart rather
general, uncontested information about works of art, articles often present
the original arguments of one particular scholar. If you are assigned such
articles, you may be asked direct questions about them in the essay ques-
tion. *Ask your professor about this possibility prior to the exam.* In any
case, mentioning individual scholars and their ideas, whether mandatory
or not, is very impressive in an essay exam and will certainly boost your
score. For these reasons, it is important for you to do the assigned read-
ings and to memorize their key ideas.

What is the best way to do this? As with memorizing names and
dates, make up flashcards. Write the author's name on the front of the
card and a few main ideas from the reading on the back. Don't write down
a great deal (it will be difficult to remember). Just one or two key sen-
tences to spark your memory should suffice. Here are two final hints on
answering the essay question:

1. Read the essay questions! If lead-in questions are provided for you, do
not ignore them! They will help you to shape and focus your essay.

2. First, answer the questions you know best. If you have a group of essay
questions to answer, read all of them first and then start by answering the ones
you know best. You will be at your freshest.

The Unknown

Another common component to the art history exam is the unknown. As
mentioned at the beginning of the chapter, when giving an unknown, your
professor will show you a work of art that you have not seen before.
Generally, you will be asked to make some guesses about the work, such
as its author, date, and the period in which it was produced, and then you
will be asked to provide reasons for those guesses based on similarities
with works you *do* know.

Students often hate unknowns because unlike in other sections of the exam, they cannot know the precise answer. But professors don't give you unknowns in order to torture you or shake your confidence. In a way, in fact, knowing the precise answer might *not* really help you. It is much more important to know the works you are responsible for very well, and to know what makes them *typical* and *characteristic* of their artist and period. This is the key to studying for the unknowns.

Consider an example. Let's say that the unknown pops up on the screen. You observe immediately that it looks a lot like the prehistoric figurine, *Woman from Willendorf* (fig. 16). How would you to write an answer for this unknown on the exam? Here are two answers, one weak and one strong:

Answer 1: This is a prehistoric fertility goddess dating from 22000 B.C.

This might seem like the right answer. After all, the student identified the correct date and function of the work. However, he has provided no explanation for his guess. He has not revealed how he arrived at his particular identification.

Here is a better answer:

Answer 2: I think that the work is from the prehistoric age. It appears to be a very small sculpture (a figurine). Also, it uses abstraction, particularly in the repetition of the round forms of the hips, breasts, and thighs, and in the decreased focus on other forms like the hands and arms. The basic subject matter (a large woman) and the focus on reproductive parts of the body make it similar to the *Woman from Willendorf*. And so for this reason, I would date it to the prehistoric age, around 22000 B.C.

Why is this a good answer? The student has done more than just guess a date and period for the work, as in answer 1. He has considered it in comparison to a work he knows, the *Woman from Willendorf*. Moreover, the student has been *specific* about what makes the work look like the *Woman from Willendorf:* the subject matter, the type of figure used, the use of abstraction. So succeeding at an unknown is not, as many students think, about poring over works that you don't know in order to impress your professor with the correct identification.

Writing an Answer for the Unknown. You will probably be given at least five minutes to write an answer for the unknown. Here too, then, you

need to organize your thoughts. I am not suggesting that you draw up an outline—for such a short section, it is not necessary. However, following the steps below will help you write a clear, thorough answer:

1. Start by describing the work in specific terms. What is it?
2. Compare it to a similar work that you know, citing all the ways in which it is similar.
3. Conclude by making your speculations about the work, based on the similarities you have outlined above.

Finally, here are some general hints on taking exams in an art history course:

1. Bring several pens and pencils.
2. If blue books are used, take an extra one.
3. Sit toward the front to make sure you can see well.
4. During the exam, stretch out your writing hand periodically to avoid cramping up—this is a common complaint, and quite serious if you have another exam immediately afterward.
5. Do not socialize with other classmates before the exam—this may disturb your memory.
6. Eat and sleep enough before the exam! This is crucial to the recollection of information.

As I mentioned in the beginning of this chapter, each professor is different and each exam is different. So again, make sure you discuss the exam with your professor first before beginning to study. And good luck!

5

Research Projects
in Art History

Some introductory art history courses will require you to undertake research for a term paper, presentation, or project. This chapter will focus on some of the most common problems students confront when given this kind of assignment: How do I formulate a research topic? How do I do research in art history? What is the best way to take notes on a reading? It will also provide tips on writing a research paper and include, in a final section, advice on critiquing art-historical scholarship.

In some art history survey courses, you may be required to undertake a research assignment. It is doubtful, however, that this will be an extensive project; more likely, you will be asked to produce something rather modest, such as a paper of not more than six pages or a short presentation. The precise nature of the assignment will vary from class to class. What remains consistent, however, are the problems students face when confronted with the task. Choosing a topic of research, locating bibliographical sources and images, taking notes—all these steps can cause confusion and frustration. This chapter will guide you through the process.

FORMULATING A TOPIC

It is possible that your professor will assign a research topic or provide you with a list to choose from. In some cases, however, you may be allowed to select your own. You may consider yourself lucky—finally, you have the freedom to work on what you wish, rather than on what is dictated by the professor! Formulating a good topic, however, is not an easy task. Pick too general a subject, like the role of women in art, and you will end up with a research project involving hundreds of books and articles, and, ultimately, a paper that is too long or very superficial. On the other hand, if you choose a topic that is obscure, such as the iconography of the chicken in medieval Armenian manuscript illumination, you may not find anything written on the subject at all.

To ensure that your paper will be of manageable size and scope, it is usually safest to *focus on a single work of art,* preferably one that was discussed during the course. Choosing a single work as your subject ensures that your research will have certain fixed boundaries. Within these parameters, however, you will still have the freedom to discuss any aspect of the work, such as style, influences on the artist, iconography, and so on. How to choose your work? Flip through the images in your textbook. Which of them speaks to you? Which elicits the strongest ideas or emotions from you? Which are you most curious to learn more about? Follow your instincts; remember, you will be looking at this work of art awhile! Finally, make sure to check with your professor before beginning the research process; he or she will be able to predict the feasibility of the topic and provide you with further ideas on shaping it. Also, remember that even though a single work will be your focus, your goal in a research paper is not simply to *describe* it (a common student mistake). A research paper, as its name implies, must involve actual *research*—the consultation of scholarly sources.

FINDING BIBLIOGRAPHIC MATERIALS

Having defined your topic, now you must gather your research. Where do you go? How do you begin? In ancient times, you would immediately march to the library card catalogue. Now, almost without exception, you plant yourself at the computer and do some quick keyword searching. As you probably already know, the internet offers much more than entertainment—it is an incredibly useful research tool as well, lining up relevant websites for you at the touch of a button. Even professors will admit to using internet searching devices for their own work. (I am one of them.)

Finding Images on the Internet

For finding images, the internet is particularly convenient. Let's say you are searching for an image of Picasso's *Les Demoiselles d'Avignon* (fig. 13). In the old days, locating a reproduction of this painting would have entailed a many-stepped process, starting with a trip to the library, than finding books on Picasso, and finally browsing them until you found the relevant image. If you had chosen a less famous work, it is quite possible that no books in your library would offer a reproduction, and you would be forced either to order a photograph from the museum or gallery where the painting was held (an expensive and time-consuming process) or to borrow a book with the image on interlibrary loan.

Now, however, you can run an internet search specifically designed to find images. This feature often appears on the homepage of your search engine (sites such as Google and Yahoo have this capability). Type in "Picasso" and "*Les Demoiselles d'Avignon*" and click on "Images" and you will come up with numerous sites, among them that of the Museum of Modern Art, in New York, where the painting is located. If your image is more obscure than a Picasso, you still have a good chancing of finding some reproduction of it—museums and galleries, both large and small, often place digital versions of their collections on the web. Textbooks such as Marilyn Stokstad's *Art History* also have websites with extensive image libraries. You are particularly lucky if you are interested in new media artists, whose work is sometimes only available on the web.

A Few Tips on Using Internet Images

1. Bookmark the site. The nice thing about books is that if you lose your place, you know that you can find it again before very long. But finding a website you forgot to bookmark after an initial visit is often a far more complicated proposition, involving typing in precisely the same search terms, in precisely the same order, and sifting through the sites until you find the right one. Of course, that is assuming that the website has not in the meantime disappeared (another potential hazard). For these reasons, it is essential that you bookmark the site and download and save the image in a separate file as soon as you are able.

2. Read and reference the copyright. If you are going to download and print the image to use in your paper, make sure that you cite the institution that has rights to it. Just as you would cite the source for a direct quotation in your paper, also do so for your image. Include the citation in a caption below the image.

3. Check image quality. It is often the case that images appearing sharp on the computer screen are disappointing once printed out. This has to do with the quality of the original photograph, the manner in which it was scanned, and the

capabilities of your computer and printer. The way in which the image is stored on the website will also affect quality. For sharper images and more detail, look for images in **JPEG** (Joint Photographic Experts Group) files rather than in **GIF** (Graphic Interchange Format), which tend to be of lower resolution. Make sure to compare several versions of the same image before you choose one. By comparing them, moreover, you will have a large enough sample to make sure your image is not cropped or abbreviated in some way—another common problem with images on the internet. If you simply can't find a good enough image, give up, go to the library, and find books with the relevant illustration. Despite the widespread improvement in the resolution of web images, photographs still remain, overall, of consistently superior quality. Here are some useful sources for finding internet images:

> The Virtual Library Museum Pages (VLMP) : *http://www.icom.org/vlmp/*
>
> WorldWide Arts Resources : *http://wwar.com*
>
> Museum Computer Network : *http://mcn.edu/*
>
> The Art Museum Image Consortium (AMICA) : *http://www.amico.org*

Finding Scholarly Work on the Internet

Image searching is only one of several ways in which the internet can help your research. You can also use it to locate scholarly work about your topic. Not only are entire art history bibliographies now available online, but it is also possible to read articles from academic journals there as well. *What will be difficult, in fact, is evaluating and prioritizing the abundant textual information available.* Faced with a myriad of websites, it is easy to waste hours surfing the web. To avoid this, it is best to be systematic. The following guidelines should help you navigate through internet chaos.

The Different Kinds of Art-Historical Publications. Before beginning, be clear about what you are looking for. Art-historical research comes in many forms. Below is a list of the most common.

1. Books. Art-historical *books* are usually published by a single author and express a particular point of view on a specific topic, such as an artist, artistic period, or theme. Each chapter usually addresses a single aspect of that topic. Footnotes (or endnotes), as well as a bibliography, are also generally included.

> Example: Beardsley, John, *Earthworks and Beyond: Contemporary Art in the Landscape.* New York: Abbeville, 1984.

2. Book Reviews. These are not your grade-school book reports! In an academic *book review,* the author does more than simply tell the reader whether he

liked the book or not. Quite substantial in length, book reviews often include a thorough summary of the book as well as a critique. In assessing the book, the review author will evaluate the success and persuasiveness of the arguments, consider the validity of the methods used, and check the factual accuracy of the statements. If you wish to get a different perspective on a book or get a sense of its content without committing to reading the whole text, book reviews are extremely useful. The majority of book reviews are published in academic journals (see number 5 "Journal Articles," below).

> Example: Walter C. Kidney, *Pittsburgh's Bridges: Architecture and Engineering.* Pittsburgh, PA: Pittsburgh History & Landmarks Foundation, 1999. Reviewed by Eric DeLony, *Journal of the Society of Architectural Historians,* 59, 4, 2000: 561–562.

3. Exhibition Catalogues. *Catalogues* are book-length, collaborative efforts that document a museum exhibition. Although one or two individuals are often named as editors, museum catalogues are usually written by a team of scholars. They typically begin with an introduction or series of introductory essays followed by photographs of works from the exhibit. Each image is accompanied by a description, called a catalogue entry, authored by individual scholars. An extensive bibliography is typically found at the end of these books. Most often, catalogues are published by the museum or museums in which the exhibit was held.

> Example: *Art Nouveau 1890–1914.* Ed. Paul Greenhalgh. London and Washington, DC: Victoria and Albert Museum and the National Gallery of Art, 2000.

4. Critical Anthologies. **Critical anthologies** consist of a series of essays written by different scholars. These contributions are scrutinized by an editor or editors, who control the themes and directions of the book and generally write an introduction to it. As in the chapters of a regular book, the essays (sometimes also referred to as articles) consider different aspects or examples of a single theme. However, in this case, they can be read as single, self-enclosed articles, as in an academic journal (see number 5, below).

> Example: *I, Claudia: Women in Ancient Rome.*
> Within this book are a series of essays, including A. Wallace Hadrill's "Engendering the Roman House" (pp. 104–115) and D. E. E. Kleiner's "Imperial Women as Patrons of the Arts in the Early Empire" (pp. 28–41).

5. Journal Articles. In one way, *academic journals* bear a resemblance to popular magazines: both consist of a set of articles written by individual authors. However, journals are generally issued only a few times a year, and, most important, are

written by and for the academic community. Some art-historical journals, such as the *Art Bulletin,* are of broad scope, featuring articles on any topic within the field. Some are devoted to specific media, such as the *Journal of the Society of Architectural Historians.* Others emphasize a particular period, such as the medieval art journal *Gesta,* or a particular approach, such as *Word and Image,* for instance, which considers the relationship between visual and textual studies. Other journals, moreover, are known particularly for their progressive stance, such as *Art History.* Articles in journals are not published in installments and appear complete within a single issue of the journal, usually running anywhere from ten to fifty pages in length. Moreover, an article is more than simply a general introduction to a topic or a presentation of established facts. Rather, it is designed to *present a specific argument* about an art-historical subject and often to challenge prevalent scholarly opinions.

Searching Bibliographical Databases. Let's say you would like to read a scholarly article on Michelangelo's *David.* Bibliographical databases will be the singlemost useful tool for this purpose. Many are available on the internet; in some cases, access to the information is limited to subscribers only, and it may be necessary for you to visit the site through your university, entering a userID and password. To locate the sites accessible to you, go to your library's homepage. There, you will find a listing of bibliographical databases, often indexed from A to Z, that range in subject from the sciences to the humanities. For bibliographical searches in art history, look for sites that follow.

Art Abstracts: **http://vnweb.hwwilsonweb.com/.** This database, which also exists in printed form, is a repository of scholarly articles on all aspects of art history published since 1984, culled from periodicals, yearbooks, museum bulletins, and exhibition listings. One of the most comprehensive of the art history databases, it also features **academic abstracts** (summaries) of each of its entries. This is an invaluable feature: reading an abstract before hunting down the article itself will save you precious time, allowing you to rule out works that are irrelevant or uninteresting to you. (Often the article title alone will not reveal sufficient information to make this kind of judgment call.)

Bibliography of the History of Art: **The BHA/Eureka on the Web.** Begun in 1991, this database is predominantly geared to those interested in the art of the Mediterranean and Europe from the fourth century A.D. to the present time. Works cited include books, book reviews, and articles from over 1,750 journals. Abstracts also accompany most of the entries.

For Modern Art: **ART-Bibliographies MODERN.** This online database includes articles, books, and exhibition catalogues on modern art and architecture published since 1974.

For Architecture: **Avery Index to Architectural Periodicals.** The *Avery Index* is the most important and comprehensive database on architectural history. The online version covers articles published from 1934 to the present in journals on architecture and related subjects, such as urban planning, historical preservation, and interior design.

Arts and Humanities Citation Index. *The Arts and Humanities Citation Index* (A&HCI) is a database of over 1.4 million records from 13,000 arts and humanities journals. Although the computer index goes back only to 1982, it is incredibly comprehensive—not only are the texts of articles indexed, but also the footnotes and bibliographies.

ArtSource: **http://www.ilpi.com/artsource/.** Artsource is a comprehensive site with both academic and commercial elements (including an online bookstore). For the purposes of art research, it includes three important features (clickable from the homepage): (1) online catalogues of major art and architectural libraries in North America; (2) a "hot" listing of bibliographical databases for art and architecture (such as the ones mentioned above); and (3) a large number of online, full-text art journals. Take care, however, when using the last item; see the paragraph on "The Trap of Internet Pseudo-Scholarship," which will follow in this chapter.

Using Internet Databases: Three Demonstrations. The above databases are wonderful tools. And they are also fairly easy to navigate. However, online searching is fraught with hidden pitfalls, and one wrong turn could lead you to hours of wasted time. To avoid this, the following section walks you through three different databases, from the beginning to the end of the process.

Example 1: Searching with Art Abstracts. Let's visit the Art Abstracts website, with the goal of researching a project on Michelangelo's *David*. Once you reach the site, you will find that it has much in common with an online library catalogue. First, you will have your choice of a "simple" or "advanced" search. As a rule of thumb, it is best to start with the simple search and then move on to more advanced methods if you have no luck. Second, you will have your choice of an author, title, subject, or keyword search. Since you have no particular author or title in mind, you could use

either the subject or keyword command. I always prefer keyword, as each database has its own way of cataloguing subject headings. Type in "Michelangelo" and "David." Using both terms, connected by the word "and," is known as a Boolean search, and will bring up all entries which contain these two terms in their titles or abstracts.

The result? The search "Michelangelo and David" brings up 20,701 items! Your immediate reaction is probably panic: how in the world are you to choose one or two articles amongst all of these? It would be incredibly exhausting to go through each one. Thankfully, some filtering has already been done by the computer. For example, Art Abstracts has icons next to each item indicating whether or not the article is located in a **peer-reviewed journal.** What does this mean? In this kind of journal, submissions for articles are circulated among two or three experts in the field, who vote on whether or not the manuscript should be published. In other kinds of journals, submissions are either reviewed by a single editor or, sometimes, simply accepted with no evaluation at all. Using a peer-reviewed publication, then, generally ensures a certain standard of quality. Also, Art Abstracts has a computer device which ranks the entries in terms of relevance—if *both* the terms "Michelangelo" and "David" appear in a title, then that title will be ranked higher than if, for example, "Michelangelo" shows up in the title and "David" in the body of the abstract.

With this in mind, let's click on the very first entry:

E. Allen, "David and Michelangelo," *Apollo* (London, England), v. 153 no. 472 (June 2001), pp. 18–39.

The entry above contains eight items. The first refers to the author (E. Allen), the second is the article's title, the third is the journal title, the fourth is the place of publication, the fifth is the volume number, the sixth is the issue number (within the volume), the seventh is the month and year of publication, and the eighth indicates the relevant pages in the journal. Judging from the title "David and Michelangelo," the article sounds promising. Let's click on the title and read the abstract:

The writer discusses Jacques-Louis David's Portrait of the Comtesse Vilain XIII and her daughter, recently acquired by London's National Gallery, which was produced in 1816 during the artist's Belgian exile. In portraying these two figures, David reworked Michelangelo's celebrated sculpture of the Bruges Madonna; above all, the common motif of the linked hands reveals the relationship between the two works. The Comtesse's letters to her husband, which date the work to the period May–July 1816, reveal precise information about

David's working methods and also about the number of sittings needed for the face and his treatment of it.

As it turns out, this article is not about Michelangelo's *David* at all! Instead, it concerns the French nineteenth-century painter *Jacques-Louis David* and his relationship to the work of Michelangelo. A different "David" altogether! Computers are fallible. Let's try again, going back to the initial search results and clicking on the second entry:

M. Hirst, "Michelangelo in Florence: 'David' in 1503 and 'Hercules' in 1506," *The Burlington Magazine,* v. 142 no. 1169 (August 2000), pp. 487–492.

This sounds more promising. Clicking on it, we find that it is: this article is devoted to Michelangelo's *David* and related projects, with special consideration of when precisely the sculpture was completed. If this topic interests you, your next step is to check whether the *Burlington Magazine* is peer-reviewed (it is) and then to see if your library carries it (as a major journal, it most likely will). If it is available, your final task is to note down the call number and all bibliographical information, including title, year, volume and issue numbers, and the page numbers. The best way to do this is to send the record directly to a printer, which saves time and also ensures accuracy. (I can't tell you how many times I have scribbled down titles and call numbers on a slip of paper, only to arrive in the stacks unable to read my own writing!) In any case, make sure you have recorded all the information accurately. The volume, issue, and pages numbers are particularly important. After finding your journal at long last, do you really want to trek all the way back to the catalogue because you forgot the specific page numbers?

***Example 2: Searching with the* Avery Index to Architectural Periodicals.** Now let's try another database, the *Avery Index to Architectural Periodicals.* Like the Art Abstracts homepage, you will first be presented with a search line. In this case, let's say you are writing about the Parthenon (fig. 20). Click on keyword search and type in "Parthenon." The result? 187 entries. So what is first on the list?

1. *Bilbao backlash* (Acropolis Museum, Athens), axonometric drawings, in *Oculus* 2002 March–April, v. 64, no. 7–8, p. 5.

Now, in judging the usefulness of this entry, let's consider the information above. First, notice that no author is given. If we clicked on the entry, we might discover the reason why—perhaps the work is a collaboration

of some kind amongst many scholars. It may be, moreover, that the work contains no actual text! As you seek out an article, make sure that the entry heading lists an author. Note also that the work contains axonometric drawings. *The Avery Index,* like most of the databases, tells you what sorts of illustrations are included in the article. Finally, consider the last item, the page range. According to the record, this work consists of only one page! Such a work is not going to be substantial enough for your research project. In general, you should seek out scholarly articles that are at least 10–15 pages in length.

But the clearest warning sign about this entry is the title. There is no indication in it that the article deals with the history of architecture, let alone the Parthenon itself. Instead of wasting time looking at the abstract, it is better to move down the list of items. The second entry is the following:

2. "Déplacer le mont Fuji"=Displacing mont Fuji /Jilly Traganou
photos, drawings, ill., maps
In: *Architecture d'aujourd'hui* 2002 Jan–Feb, no. 338, pp. 92–97.

Unless you know French, this article will also be of little use to you. And again, note that the title is not particularly substantive. As poetic as it may be, "Displacing Mount Fuji" does not reveal anything to us about the Parthenon. And again, note that the article is only five pages long. Your next step? Scan further down the list to find a title that *does* seem relevant. At number 7, we find a promising one:

7. "The Principle Design Methods for Greek Doric Temples and their Modification for the Parthenon," Gene Waddel, photos, elevations, charts, plans, reconstructions
In: *Architectural History* 2002, v. 45, pp. 1–31.

Here we have a much more useful entry. The title of the article and the journal in which it is located imply that the reading will concern the architectural history of the Parthenon. At thirty pages in length, it will also be a substantial (yet manageable) read. Clicking on the entry, we find that the abstract, like the title, suggests that the article is worth checking out. Make sure your library carries the journal, note down the relevant information, and head to the stacks.

Now, in the above three demonstrations, I assumed that you were sufficiently enamored of the final article that you concluded your search and began your journey through the stacks. But research is an organic process. Sometimes the search for a topic can lead you to one more

specific or altogether different. In a sense, the online databases encourage this sort of browsing. For example, just below the abstract for the Parthenon article is a list of related subject headings:

1. Temples, Greek, Greece, Athens, acropolis, Parthenon
2. Architecture Orders Doric
3. Architecture-Composition-Proportion-etc., Greek
4. Temples Greek Greece
5. Capitals (Architecture) Doric Greece
6. Columns Measuring Greece

By clicking on any of these, you can search for works that deal with a specific theme. Let's say you are interested in architectural proportions. Clicking on item 3, you will find additional articles that address this issue. Be open to this kind of browsing—often it is the way to shape your topic further and locate the most interesting scholarship.

Example 3: Searching with the **Grove Dictionary of Art: www. groveart.com.** Unlike the other two examples, the *Grove Dictionary of Art* is not intended as an online bibliography, but rather, as its name indicates, an actual dictionary including over 45,000 entries on all aspects of art and artists (including photography and non-Western art). If you want to begin your research process with a concise summary of the topic, this is the ideal starting place for you. Each entry, moreover, is accompanied by a bibliography, allowing you access to more specialized studies.

Let's say you have been assigned to give a short presentation on the modern abstract artist Mark Rothko. As in the previous databases, the homepage features a search box under which are the subheadings "full text," "biographies," "bibliographies," "external image links," and so on. Again, since you are beginning an initial search on the subject, it is best to start with the simplest and broadest of terms. This generally means the first term on the list, in this case, "full text." At the next line, type in "Rothko" and then click "search." Sixty-seven items come up, which are sorted, again, by relevance. Here are the first three:

1. 86% Rothko, Mark, Life and Work. In 1913 he emigrated with his mother and sister to the USA, where they were reunited with his father and two older brothers, who had settled in Portland, OR, a few years earlier.

2. 81% Rothko, Mark: Mark Rothko Foundation
The Mark Rothko Foundation was incorporated in 1969 and was the major beneficiary of Rothko's estate, comprising about 800 paintings and works on paper plus 1,200 sketches of . . .

3. 81% Menil, de
American collectors, of French birth. John de Menil (1904–73) and his . . .

Note that the greater the percent number, the higher the relevance. Already, you can see that at 86%, the first item is more relevant than the others. A quick scan of the second and third items bears this out. Number 3, "de Menil," does not appear to be directly related to Rothko at all. Note that the word "Rothko" does not even appear in the first few lines of the entry. From what we can see, the entry seems to concern a collector (by the name of John de Menil) who possessed works by Rothko. As interesting as this might be, it is tangential to your topic. Number 2 is somewhat more relevant, but has to do with an organization devoted to Mark Rothko rather than a art-historical discussion. Obviously, number 1 is the right choice. Clicking on that, you get a five-page summary of Rothko's life and work. Alongside these pages, moreover, is a bibliography you can consult for further reading. Finally, as in the case of the *Avery Index,* a series of related topics are listed below the summary. If you wanted a quick introduction to the artistic movement to which Rothko belongs, you could click on the line "Abstract Expressionism."

Tips for Internet Research. Based on the above examples, here are some quick tips to facilitate your search:

1. Is the publication of good quality? There are many, many journals and books out there. Some, however, are more reliable than others. As discussed previously, if you are considering a journal, always check to see whether it is peer-reviewed. Some of the best journals are *Art Bulletin, Art History,* and *The Burlington Magazine.* Regarding books, always favor university publishers. If it is a museum catalogue, it should be published by a major museum or library. Look out, in general, for publishers with goofy names.

2. Does the article sound appropriate? Is it in English or another language that you can read? Does the title contain any mention of the topic you are interested in? Does it sound engaging to you?

3. Is the article the right length? It should be at least ten pages in length. If you are pressed for time, also make sure that it is not too long.

4. Is the article illustrated with photographs, diagrams, and maps? Generally, this information will be included in the entry. Look for articles that have at least some illustrations.

5. When was the article published? If searching for a single article on a subject, I generally advise students to consider newer work. Reading articles published in the 1980s or more recently will have several advantages: these

works will most likely take into account previous scholarship, with discussions of and references to all relevant older publications. In some cases, moreover, the article will reflect new information or evidence resulting from scientific or archaeological inquiries. Scholarly methods will also be more up to date.

6. Be patient and don't be afraid to browse until you find what interests you. When faced with discouraging initial results, students tend to give up. Allow yourself time to go down a few dead-end streets. This is a necessary part of the research process. With perseverance, you will come upon a relevant and interesting article.

7. The trap of internet pseudo-scholarship. In doing art historical research, many students will simply type their topic into a general search engine like Google. There are several drawbacks to this approach. To illustrate this, let's type in "Picasso" at the Google home page. The result? 1,380,000 entries! Here are the first five:

1. Picasso! 100's of Picasso Prints and Posters for Sale!
2. The On-line Picasso Project (an online catalogue of the artist's works, biography, and bibliography, and image links)
3. Club-Internet—le club le plus ouvert de la planète!
 (Club Internet—the most open club on the planet!)
4. Artcylopedia: (an online encyclopedia of artists)
5. Pablo Picasso (Text from Thomas Hoving's *Art for Dummies*)

As you can see, the results are quite a mixed bag. Two clear dead ends are sites 1, an online poster store, and 3, a European internet access company. And site 4, an extract from a popular amateur guide to art history, is too remedial for your purposes. Sites 2 and 5 are more relevant. Both contain online biographies of Picasso, a library of images, and bibliographies. Site 5 is particularly useful, as the bibliography features digitized articles on Picasso from the *Art Bulletin* and other journals.

As a rule of thumb, however, you will find it less convenient, less predictable, and more time-consuming if you undertake research for your topic with a general search engine. The same goes for using online articles. While a great number of digital journals are perfectly legitimate, the online scholarly community is still in its nascence, and there is no fail-safe way to ensure the quality of the texts. You don't need a degree from kindergarten, let alone a Ph.D., to write online. So why waste your time reading a text that might be speculative or even completely bogus? With a short research assignment, it is all the more crucial that the materials you use are from established sources. For this reason, I would suggest that you refrain from random surfing and use the internet to find images and to conduct bibliographical searches, using the databases mentioned previously.

The Library Visit

There remains, of course, the old-fashioned way to do research—visiting your library. While surfing the net in your dorm room on a snowy afternoon might seem a good deal cozier than an expedition across campus, there are important advantages to a library visit. First, if you have a question, you will be able to speak to a living, breathing human being. Don't be afraid to use librarians to help you. And don't think you must have a perfectly formulated question in order to approach them. Just let them know that you are beginning research on a new topic and are confused about how to begin—they will, most likely, be eager to assist. If you are lucky, you may even be able to speak with an *art librarian;* that is, a library professional with specialized training in art and architectural history.

But perhaps the best thing about the library is the opportunity it gives you to browse. As wonderful as the bibliographical databases are, they cannot yet replicate the feeling of letting your eyes skim over titles on a bookshelf. I find that despite all the amazing advances in technology, one of the best ways for students to begin research remains going to the stacks, locating an established journal like the *Art Bulletin,* and sitting down with a few of the most recent issues. As prehistoric as it sounds, I guarantee you that using this method will quickly yield at least one article that is insightful, up-to-date, and relevant to your topic.

Moreover, all the bibliographical databases mentioned previously exist in print version (although some libraries have ceased subscriptions to these printed versions because of the convenience and popularity of the online versions). If you wish to use the print versions, look for them in the reference section of the library. Also, be aware that in the process of going online, some of the series merged and/or changed their names, as in the following two cases:

1. Art Abstracts was previously called Art Index.

2. The *Bibliography of the History of Art* (*BHA*) started life in 1991, the result of a merger between two indexes: the *Répertoire d'art* (Repertory of Art) and (*Répertoire internationale de litterature et de l'art* or *RILA* (International Repertory of Literature and Art). Both cover Western art from the fourth century A.D. to the present.

Here are other useful reference works that exist in print form:

John Fleming, Hugh Honour, and Nikolaus Pevsner, *The Penguin Dictionary of Architecture,* 4th ed. New York: Penguin, 1991.

James Hall, *Dictionary of Subjects and Symbols in Art*. New York: Harper & Row, 1979.

Lois Swan Jones, *Art Information: Research Methods and Resources,* 3rd ed. Dubuque, IA: Kendall/Hunt, 1990.

Ralph Mayer and Steven Sheehan, *The HarperCollins Dictionary of Art Terms and Techniques,* 2nd ed. New York: HarperPerennial, c.1991.

Nikos Stangos, *The Thames and Hudson Dictionary of Art and Artists,* rev. ed. World of Art. New York: Thames and Hudson, 1994.

Reading and Note-Taking. Let's say you have completed your online or library search and have located an appropriate reading. What is your next step? This depends on whether or not your library is circulating (meaning that books are allowed to leave the library) or noncirculating. If you are dealing with a book in a circulating library, you should, obviously, check it out. If it is a noncirculating library, however, you have two options: stay in the library and read it, or photocopy the chapters you need and bring them home. If you are dealing with an article, you should photocopy it regardless of whether or not you can check the journal out (and many circulating libraries have special rules about the circulation of journals). In either case, *I highly recommend photocopying your reading:* having your own photocopy means that you will be able to consult the article at any time and in the comfort of your own home. Second, you will be making notes *directly on the text,* an important part of the reading process.

Your reading will also, most likely, be accompanied by illustrations (either photographs or drawings). Make sure you locate them—sometimes publications group the texts of an issue in one section and all the illustrations in another. Also, remember that a photocopied image, in general, will be of inferior quality when compared with the original. Take special care in copying photographs: if your photocopier has a "photo" mode, make sure to use it; if not, go to the *light to dark* feature on the machine, and *lighten* the photocopy just a little bit. It is best to check each page after you photocopy it and fine-tune the process until you produce the best-quality images. If, no matter how hard you try, the photocopies are still of inferior quality, look through the originals very carefully before you leave the library and revisit them if you need to. Alternatively, you may be able to find adequate versions of the illustrations on the web. You may think I am being a bit fussy here, but there is nothing worse than discovering that the article you are reading is focused entirely on a little detail that you can't see! The main point is that you should understand precisely what the author of the article is pointing out in his or her discussion of an image.

Here are some additional tips for researching in the library:

1. **Make sure to copy the title page of the book or journal as well as the reading itself.** Doing so will give you a cover and remind you of its source. Also, title pages generally contain bibliographical information such as the year and month of publication, and in the case of journals, the volume number and issue number.

2. **Take care not to crop the text or page numbers of the original.**

3. **Don't forget to copy all the footnotes as well.** Footnotes can often be just as important as the main text.

4. **Staple or bind the pages together as soon as you can.** It is incredibly easy to lose or jumble pages, particularly a problem if page numbers have been accidentally cropped off!

The Reading Process

1. **Finding the right place to read.** The right physical environment is crucial to the reading process. Some students prefer the library or a study area. Others like to work in a more social setting, like a café. I prefer my apartment. In general, try to choose a place that is quiet—a place in which you can hear yourself think. Reading demands prolonged concentration, and frequent interruptions from noise or commotion will slow you down and impair your comprehension. Also, choose a place where you can be comfortable; a library may be quiet, but if your back is becoming stiff from a hard wooden chair, you will not be able to do your work.

2. **Read the text once, straight through.** This may take some patience and courage. Scholarly books and articles assume a working knowledge of the general field and often a high level of familiarity with the specific subject treated. The writing may be dense and technical, and texts in foreign languages may not even be translated. All this may lead you to put down your reading in despair after only a few paragraphs. But be patient. Expect to get a little lost. Take your time, keep a dictionary at your side, and write down questions on a separate page when they arise.

3. **For every paragraph you read, write a short marginal summary.** To aid your comprehension, make marginal summaries of each paragraph you read. Why? When a text is difficult, you will find that you spend so much time on one paragraph that you have forgotten what was written in paragraph before! Writing short summaries ensures that you have a sense of the meaning of each section, and that you understand how the author is proceeding from point to point. As you compose these summaries, moreover, try not to transcribe them precisely from the text. Read the entire paragraph, decipher its main point, and then write it down. This will also help you to internalize the information.

Paragraph summaries are also helpful when it comes time to analyze the argument. Remember, scholarly writing is not just a neutral presentation of objective facts. Rather, the author is building a case, moving from paragraph to paragraph, in order to prove his final point. While the text might appear to you as perfectly logical and objective, keep in mind that *this is precisely the goal of the author:* to make it seem as though his or her conclusions are self-evident and transparent. More on this subsequently, in "Analyzing Scholarship."

To give you a sense of how to write a paragraph summary, here is an extract from a recent article on Andy Warhol. A sample paragraph summary appears below it.

> Sometime in late 1948 or early 1949, during his final year of art school at the Carnegie Institute of Technology in Pittsburgh, Andy Warhol changed his style. According to one of his classmates, he had been working in a manner indebted to Aubrey Beardsley that had earned him respect and interest from his fellow students and the support of the two most widely respected instructors when his friend and classmate Philip Pearlstein convinced him to look for a new influence. Apparently, Pearlstein informed Warhol, some of the more conservative faculty did not approve of the influence drawn from Beardsley. This criticism was probably not focused only on the decorative prettiness of the Beardsleyesque drawing style—from his art school days through the 1950s, Warhol regularly made drawings with long and flowing fine lines, intricate scrolls, and intermittent strands of ink—or on his use of untoward or indecorous subject matter, something Warhol was routinely enthusiastic about as well. Also suspect, no doubt, was the Beardsley legacy of tainted ambition for the social place of art. The charged mix of innocent form and less than decorous subject matter in Beardsley's delicately drawn grotesqueries had served various ends in the 1890s, of course not the least of which was to threaten some of the loftier social distinctions made in the name of art by opening its preserve to baser social ambitions and practices: "May not our hoardings claim kinship with the galleries, and the designers of affiches pose as proudly in the public eye as the masters of Holland Road or Bond Street Barbizon," he could propose in 1894, for example, while savoring the imagined affront that "London will soon be resplendent with advertisements."

> (Blake Stimson, "Andy Warhol's Red Beard," *Art Bulletin,* September, 2001, vol. 83, pp. 527–547, p. 527)

Paragraph Summary:

Between 1948–1949, while in art school, Warhol changed his style. His old style was influenced by artist Aubrey Beardsley (British, late

nineteenth century). This style was criticized by the faculty for its "prettiness" (fine, intricate lines and scrollwork) and rude subject matter. Also, faculty may have sensed in Warhol's work the same attitude that Beardsley held toward the fine arts—that there should be no distinction between high and low art (such as advertisements). Both artists wanted to break down social hierarchies through art.

Note how the above summary does not go into details about Warhol's artistic change, such as how it came about or who prompted it. Beardsley's pronouncements on art have also been kept to a minimum. This kind of summarizing can be difficult for a student, because you might not feel confident that you can identify what is a detail and what isn't. This skill will develop over time, however, as long as you understand the meaning of each sentence. To do this, it might be necessary to stop reading and consult a dictionary or other references—for instance, you might need to look up the artist Aubrey Beardsley (*www.groveart.com* would be a good choice in this case). But again, be patient and go slowly. It is much better to understand half an article with total comprehension than to read an entire article with only a fuzzy sense of its meaning. And understanding one paragraph will give you the confidence to proceed to the next.

A final note on the summaries: keep them short and in your own words. In an effort to be thorough, you will be tempted to repeat the author's language verbatim. This will lengthen your summaries, making them harder to remember and also more difficult to squeeze into the space of a margin.

4. When the author refers you to an image, look at it! When you are reading page 3 and the author refers to an image illustrated on page 5, it can be tempting simply to continue reading. Don't! As with the writers of other textbooks, the author of your art history text will use images throughout, moving from one to the next to make specific points. If you don't follow the author's cue, you risk losing an important element of the argument.

5. Do not ignore the notes. As mentioned, your reading will be accompanied by footnotes (below each text page) or endnotes (at the end of the text). In some cases, they are simply used to cite sources, as is often the case with student papers. At other times, however, they serve a more important function: to allow for a digression that would distract from the argumentation if placed in the main body of text. Sometimes these digressions involve directions of study that the author considers promising but has not yet explored. Footnotes and endnotes can also be good hiding places—when scholars possess evidence that runs counter to their main thesis, they will often place it in the notes. This point will become important when it comes time for you to critique the text.

6. If you are stumped, ask your professor! So you have read and re-read, looked up every unfamiliar term, studied the images and notes, and you are still lost. This is the time to approach your professor or teaching assistant. When doing so, however, it is advisable to be armed *with specific questions* about the work. This way, it will be clear that you have done "due diligence" in trying to find answers, and you will make it easier for your professor to help you.

SEVEN TIPS FOR WRITING THE RESEARCH PAPER

As mentioned previously, art history research assignments can take many forms, and your professor is your best guide as to how to go about your particular project. If, as is often the case, you are writing a paper, here are a few general hints that should assist you in the process. Keep in mind that these tips refer specifically to writing a *research* paper; for more advice on writing in general, see Chapter Three, "Putting Words to Images: Mastering the Response Essay."

1. Resist the tyranny of the outline and just start jotting. As a child, I remember learning how to write the classic research paper: gather your materials, write notes on index cards, create an outline with information from the note cards, and then begin writing the rough draft. However, for most of us (whether we like to admit it or not), the writing process is not so tidy. Let's take the outline method, for example. Outlines serve a very important purpose—to help you prioritize and organize your information. Often, however, they are rather rigid. For someone who is just formulating their thoughts on a subject, this rigidity can be discouraging and stifle creativity. If you find that you are not getting anywhere with your outline, I advise you to dispense with the Roman numerals and indentations, and just start jotting (often called freewriting). Then divide these jottings into different sections. The organization of your paper will slowly emerge.

2. Learn to throw out your information. As the structure of your paper surfaces, it will most likely be necessary to discard some information that you have gathered during the research process. Perhaps you find that some of the marginal summaries you created are not related to the topic of your paper. You might think to yourself, "As long as I have collected it, shouldn't I try to stuff it in somewhere?" No. The teacher is more interested in the clarity and flow of your paper. If you feel that you absolutely must include the information, do what scholars do: put it in a note (see the guidelines that follow).

3. Start writing before you are ready. Having formulated a basic structure for your paper, you should immediately begin the rough draft. Anything later than immediately is procrastination. I did a fair amount of this when I wrote my doctoral dissertation. I had several excuses for delaying writing, such as, "I need to wait until I feel inspiration," "until I am in a better mood," "until I receive a

book from interlibrary loan," or "until the caffeine kicks in." There were many other such excuses. Finally, however, I had a revelation that ended the procrastination. I pass it along to you in the form of a mantra, which you should repeat to yourself at moments of weakness: "This paper (or dissertation or chapter) is not going to get any better if I wait."

Perhaps you might find it fatalistic. However, it is absolutely true. Your paper will not magically improve if you wait until you feel like writing. Start now, even if you are tired, hungry, depressed, or hungover. Don't worry about the quality of your ideas or your writing—you can return to these things later. For now, just get something down.

4. Don't ramble. Getting a good grade on your paper will be related, in part, to how much your writing annoys or frustrates your professor. And aside from grammatical and spelling errors, there is nothing more frustrating and annoying than a rambling paper. I can't tell you how many paragraphs I have read that start with one idea and wind up on a completely different subject. The best way to make sure that you don't ramble is always to remember your thesis statement. Repeating it often will help to keep you in line. Another way to avoid rambling is to make sure you organize your paragraphs. Each one should deal with a separate subject. When you start a new subject, start a new paragraph!

5. Number your sentences. It is crucial that your paper flows from one point to the next. How to achieve this? Although it seems extreme, it is very helpful to actually number your sentences. Each one should contain a single idea or point, and each should proceed logically from the next, as though in a mathematical formula.

6. Catch your errors before handing in the paper. You know the scenario. You have just spent hours writing your paper, which is due tomorrow. Now it is time to proofread. As your eyes skim over the text, you are thinking, "Yes, yes, I wrote that, yes" in response to everything you have written. Your proofreading is done. Yet when you get the paper back, it is marked up with corrections. Why? Because it is very, very difficult to catch mistakes when you have just written a paper. Not only are you probably tired, but you have also spent too much time with it to see it objectively. Therefore, the best way to proofread is by putting the paper away for a while. Read something else. Work on another assignment. Later, when your mind has been totally distracted, return to it. If you have less time, you might consider reading the paper sentence by sentence, but *backwards*. This will force you to pay attention and shake you out of the habit of skimming. Another tactic is to read your paper aloud. This is particularly useful for highlighting typos and catching awkward writing. Finally, try exchanging papers with someone in the class that you trust. Not only will you get a second evaluation of your work, but scrutinizing someone else's paper will also sharpen your own proofreading skills.

7. Cite your sources properly. An important component of writing the research paper is learning to cite your sources. When and what should you cite?

First, and most obviously, *any time you quote from a text.* Second, you should cite *all information that you would otherwise not intuitively know from looking at the work.* This includes, for example, *specific facts about works of art and artists.* For example, even the museum caption that discusses the life of an artist should be cited, because one doesn't intuitively know that he attended the Academy Julian or that his grandchild was the model for the painting. You should also cite *original scholarly ideas.* For example, if you write that Gothic architecture is composed of clustered piers, pointed arches, and vaults, you do not need to cite a source (you can glean this just from looking at the buildings). However, if you have been reading Erwin Panofsky's *Gothic Architecture and Scholasticism,* which connects the complexity of Gothic architecture to specific intellectual and philosophical trends, a citation is necessary. Since you are new to the field, it will take some time to discern between common knowledge and original ideas. When in doubt, however, always give your source. Plagiarism is a serious offense which could cause you to fail the course or, at worst, be expelled from your institution.

Formatting Your Citations

Now that you have determined *when* and *what* to cite, the next question is *how.* For many students, this question gets pushed aside in the mad rush to finish the paper. Granted, source citation is not the most exciting aspect of taking art history. But a paper that is improperly documented will annoy your professor and damage your grade. Yet it's easy enough to get it straight.

Some art handbooks contain entire chapters on how to cite sources. The following section is simply meant as a quick and easy guide to the basics—if you need more assistance, however, you should consult Henry Sayre's *Writing About Art,* pages 89–95 and Marilyn Wyman's *Looking and Writing,* pages 73–81.

Step 1. Assemble all the sources you used for your paper. There is nothing more frustrating than finding wonderful information, and copying it all down carefully, only to find that a week later you cannot remember exactly where you found it.

Step 2. Ask your professor what format he would like for the citation of sources. It will probably be either that of the Modern Language Association (MLA) or that found in the *Chicago Manual of Style.*

MLA Citation Guidelines. If you are using the MLA, you will not be using footnotes—instead, you will cite your sources *in the text of your*

paper itself. How does this look? The following example is a quotation from a scholarly article:

> Sometime in late 1948 or early 1949, during his final year of art school at the Carnegie Institute of Technology in Pittsburgh, Any Warhol changed his style. (Stimson 527)

Here, then, you present the quotation and follow it with the author's name and the page number in parentheses.

If you mention the author's last name in your text, you would only include the page number of the source:

> Stimson writes that Shirley Temple "provided Warhol with something that would serve him well throughout his career: she modeled a manner of operating in the world—a style or comportment—that mixed both child and adult functions and attributes, both innocence and savior faire." (527)

If you are putting the source in your own words, or paraphrasing, indicate the author's name in your text and only cite the page number. For example:

> According to Stimson, Andy Warhol was fascinated by Shirley Temple because of her combination of innocence and worldliness, qualities that would influence his own self-image and art. (527)

If you use the MLA, you will also need to create a bibliography or "works cited" page. Sources should be listed alphabetically and double-spaced, with the first line flush against the left-hand margin and the second (if there is one) indented five spaces. Titles should be italicized if possible, or if not, underlined:

Template for Citing a Book:
Last Name, First Name. *Title.* City of publication: Publishing company, year of publication.

Example:
Stokstad, Marilyn. *Art History.* Upper Saddle River: Prentice Hall, 2001.

Template for Citing an Essay in a Edited Anthology:
Last Name, First Name. "Title of Essay." *Title of Anthology,* Ed. Name of editor or editors. City of publication: Publishing company, year of publication, page range of essay.

Example:
Kleiner, Diana E. E. "The Great Friezes of the Ara Pacis Augustae: Greek Sources, Roman Derivatives, and Augustan Social Policy." *Roman Art in Context, An Anthology,* Ed. Eve D'Ambra. Englewood Cliffs, NJ: Prentice Hall, 1993, 27–52.

Note that most academic books have both titles *and* subtitles. Make sure to cite both. Also, for both books and anthologies, publication information will appear on the first few pages (before the title page) or at the very back. However, if it is easier for you, look up the book on your library's online catalogue—all the same data will appear there as well.

Template for Citing a Journal Article:
Last Name, First Name. "Title of Article." *Title of Journal,* volume number, issue number (year of publication): page range of article.

Example:
Stimson, Blake. "Andy Warhol's Red Beard." *The Art Bulletin,* 83.3 (2001): 527–547.

For further information on MLA guidelines, visit their website: *http://www.mla.org*

The Chicago Manual of Style. In the case of the *Chicago Manual of Style,* citation is created through footnotes or endnotes, rather than in the text itself. For example:

> Sometime in late 1948 or early 1949, during his final year of art school at the Carnegie Institute of Technology in Pittsburgh, Any Warhol changed his style."[1]

Note that the quotation is followed by a superscript:[1] I did this in Microsoft Word by clicking on "insert" at the menu line and then selecting "footnote." This will create a superscript in the text as well as at the bottom of the page. At the bottom of the page, you would write:

> [1]Blake Stimson, "Andy Warhol's Red Beard," *Art Bulletin* 83.3 (2001): 527.

If your next footnote is from the same source *and* page, use the term "Ibid." If the source is the same but the page is different, use "Ibid," followed by the page number: Ibid, 528.

The Chicago format for bibliographies is the basically same as the MLA. One difference: the lines should be single, rather than double-spaced.

For more information on the Chicago style, visit *www.lib.ohio-state.edu/guides/chicagogd.html*

Citing Online Resources. Both the MLA and the Chicago Manual of Style follow the format below for citing online resources.

> *For an Online Encyclopedia or Dictionary:*
> "Title of article," website address, date you visited the site (day, month, year).
> *For a Website:*
> Institution sponsoring site, "Name of Site," date entry was modified, website address, date you visited the site.

In the case of a website, it may not be possible to find all of this information—for example, you may not be able to identify the name of a sponsoring institution. Also be aware that the title of the site might sound strange. In searching for an article on Eva Hesse, the title of one window was "Artist-Biography-Hesse." Don't be concerned about this—the main point is to make sure that the citation information is as accurate and complete as possible, so that your professor can check the source if necessary. For further guidelines on citing online resources, see the *Columbia Guide to Online Style,* Eds. Janice Walker and Todd Taylor York, 1988, or the publication's website: *http://www.columbia.edu/cu/cup/cgos/idx_basic.html*

Analyzing Scholarship

It is possible that your professor will ask you to do more than simply *present* the information that you have gleaned from the scholarly sources. You may also be required to *analyze* or *critique* the work—to identify its purpose, consider the kinds of evidence presented, to assess the methods used in approaching it, and to judge its overall persuasiveness. A **critique** of a text, in a way, is similar to the formal analysis of an image that you learned about in Chapter Two. Both require you to look beyond immediate content and focus on structure.

This kind of analysis takes practice and experience. Remember that the author's peers, for whom the article is written, are trained art historians familiar with the subject and the history of attitudes about it. You, on the other hand, will most likely be encountering your subject for the first time. You also have little experience with forms of argumentation and methodology (the *how* of art-historical scholarship). Moreover, you have just

spent hours mastering complex information written in a challenging way. You will simply want, at this point, to believe everything you have read.

To write a critique, however, you must learn how to resist this tendency. So how do you do it? As with every other task discussed in this book, it is best to have a systematic approach.

Step 1: Find the Thesis Statement. The first thing you must discover is the purpose of the article, which is expressed in its **thesis statement.** Only after identifying the author's purpose will you be in a position (after you have reviewed the entire argument) to judge his or her success. How do you find it? Usually, it will comprise a few sentences appearing on the first page of the text—usually within the first two or three paragraphs. It will stand out for a number of reasons. It will often appear after a few paragraphs of description, in which the author introduces the issue or criticizes the work of previous scholars. The thesis statement might begin with a phrase like "this study will argue that . . ." or "the following paper considers . . .". Moreover, if the word "I" is ever used in the text (rare in traditional academic writing), it will be used in the thesis statement.

Now let's consider the article on Andy Warhol. As mentioned, the first few paragraphs address the changes in Warhol's style. Having discussed the influence of Aubrey Beardsley, the author then introduces her own thesis statement, in which she argues for two even more important influences: the actress Shirley Temple and the artist Ben Shahn:

> What I undertake here is an analysis of influence: the influence of two very different sorts of artists, Ben Shahn and Shirley Temple, and two very different sorts of social roles for artists, those of the moralist and the darling, on the work of Andy Warhol. It is the confluence in 1948 or 1949 of these two artistic influences drawn from distinct and largely discrete cultures of the 1930s—the fellow-traveler culture of the Red Decade on the one hand and Hollywood's golden age on the other—and its significance for Warhol's tremendously influential work of the 1960s, that is the subject of this paper.

Step 2: Identify **How** ***the Author Proves the Thesis Statement.*** Having determined the purpose of the article, now consider how the author fulfills it. This will require you to step back from the article, and to remind yourself that it is not a description of fact—it is, rather, a carefully constructed argument. While students might spend a few weeks (or less) on a paper, scholars will pore over articles for years in an attempt to get everything right. Think of a Supreme Court case in which the lawyer's choice of evidence, the manner in which he presents it, the language he uses, and even his visuals are designed to create the strongest argument possible. At the

end of an article, the scholar, like the lawyer, wants you to have no doubt in your mind that he is right.

Let's break down the task a little further and consider the issue of *evidence*. What kinds of evidence are used in a scholarly article? There are basically two types of evidence, primary sources and secondary sources.

1. Primary Sources. **Primary sources** include any data directly related to (and often contemporaneous with) the subject of the article. They are *what you study*. If you were working on the seventeenth-century Venetian painter Tintoretto, his paintings would be your primary sources. With an ancient Greek temple like the Parthenon, primary sources would include not only the building itself but also archaeological finds in the surrounding area, such as coins and vase shards. Texts, too, are primary sources. In the case of Tintoretto, we are exceptionally lucky: not only can we study his works of art, but also his diary, which has survived the centuries. In "Andy Warhol's Red Beard," primary sources include the drawings and paintings of Andy Warhol as well as an autographed photograph of Shirley Temple. Comments made about him by his classmates and professors—that is, people *directly related to* Andy Warhol—also constitute primary sources.

2. Secondary Sources. A **secondary source** is not the subject itself. Rather, it refers to what scholars and critics have said *about the subject*. In his discussion of Warhol's fascination with Shirley Temple, Stimson quotes the cultural critic Michael Moon, who has recently written about the gay male fan response to Hollywood actresses. If you were working on the *Doryphoros,* a famous Greek sculpture, your body of secondary sources would be huge, beginning with the views of eighteenth-century scholars and continuing to those of the present day.

Now, scan your article and ask yourself the following questions:

1. Does your author only consider primary sources or does he or she consult and refer to secondary sources? What are they?
2. How does the author relate the primary sources to the secondary sources?
3. Does he or she accept or agree with all the secondary sources?

Step 3: Determining Context and Methodology. Now that you have identified the kinds of sources used, you must consider what the author has *done* with them. Remember, there are infinite ways to view a work of art. The way in which your author has handled the material is referred to as **methodology.** One of the most traditional methodologies is **formalism,** in which the author makes an argument based on the visual information found in the works of art themselves. One example of formalism

is a study in which the author devotes himself exclusively to charting stylistic change in the work of the artist Rubens. Another established method is **iconography,** in which the author considers the language of signs and symbols in the work of art. The great art historian Erwin Panofsky is famous for his iconographic studies of northern European art, in which, for instance, he uncovers the veiled meaning of seemingly innocuous details like vases and flowers.

More recent methodologies focus on questions of *context.* What is the context of the work of art? In a most general sense, context refers to the world in which the work of art was produced. But one can be much more specific than that. For example, the author might deal with *historical* context, that is, with historical events or figures contemporary with the work. Related to this is the study of *political* context, which considers how dominant political ideologies shaped the work of art. The discussion might also revolve around the *physical* context, or immediate surroundings of a work, such as the Acropolis in the case of the Parthenon. If, on the other hand, the author chose to consider *social* context, he or she would consider how issues of social identity, such as class and gender, shaped a work of art.

These contextual issues are at the core of a number of newer methodologies. Among them is **Marxism,** which considers issues of *economic* context in the process of *making* a work of art. An author using this approach will ask questions such as "Who paid for the work?" "What were the circumstances of its creation?" and "What were the costs of materials and labor?" **Feminism,** on the other hand, explores the *social* context of a work, and more particularly the role of women as viewers, subjects, and artists. Hence one might explore a feminist reading of Mary Cassat's *Lydia in a Loge, Wearing a Pearl Necklace* (1879), a painting of an elegant Parisian woman at the opera, and consider how Cassat's representation of females differs from that produced by a male artist. Such a study could also include a biographical or autobiographical component, in which the scholar explored Cassat's own life in order to illuminate the meaning of her works. Additional approaches to art have been borrowed from other disciplines such as psychoanalysis and semiotics, which is rooted in structural linguistics. Although both are becoming increasingly popular, they are also highly conceptual, and it is unlikely you will be required to address them in your first encounter with critiquing art-historical scholarship.

Step 4: Judging Presentation, Logic, and Clarity. Having located the thesis statement, determined the types of sources used, and identified the author's methodology, you should have a good sense of the aims and

structure of the article. Now comes the harder part—using this knowledge to assess the strength of the article. To do this, you first must shake off your role as a submissive student who takes in new information as gospel truth. Second, you must tap into your own feelings about the article (such as confusion, frustration, disappointment, even boredom) and ask yourself whether the points raised in the article are not valid reactions to the limitations of the work itself.

The process is best illustrated with the following story: Joan, a graduate student (and yes, even graduate students have trouble with critiquing), came to me with a problem. She was assigned to critique a book on the art of Central Asia and was clearly very frustrated. She couldn't seem to come up with anything critical to say. Joan didn't know quite why she had this feeling, and became convinced that she was not sufficiently competent to complete the task. I probed a little. I asked her about the purpose of the article, the sources used, and the methodology. She replied, "Everything in the reading was about history." I asked her if there was any discussion of art, of the visual evidence. "No, I guess not."

"Well," I responded, "don't you think there should be, given the purpose of the book? Don't you see how your frustration, which you have until now accepted as your own flaw, could also be viewed as a legitimate criticism of the author's approach?" In this way, Joan began to open up to the idea that reading a work of scholarship is a two-way street; while she had to try as hard as possible to understand the content of the article, it was the author's responsibility to convince her of its truth.

When faced with the task of a critique, one common student reaction is "Scholar X is the expert—how can I disagree with anything X says? Obviously, X knows best." Certainly the author is an expert on the subject, and you will not be able (nor should you feel obliged) to argue over points that require extensive knowledge of the subject. If that were the case, you would be publishing book reviews on the subject! However, there are many points in an article where the author will present all the evidence to the reader and then offer an interpretation of that evidence. In these cases, you have as much information as the "expert." For example, a scholar might describe a work of art as "edgy" or "dramatic." Stop for a moment and look at the illustration yourself. Do you agree? And if not, what is your reaction to it? A good critique begins with *allowing yourself the freedom to disagree.*

Re-read your marginal summaries. What ideas, reactions, and feelings did you experience? What frustrated you? Where did you get lost? Now, consider what the author was doing at those particular points that might have caused these reactions. Keep in mind, however, that if you are

going to make a criticism of the author, it needs to be backed up with supporting evidence from the text. Moreover, *make sure that your critique is not a complaint.* For example, it is not acceptable to tell your reader how difficult the text was for you to read. Nor is it really helpful to say things such as "the author used very pretentious language," "the font was too small," or "there were too many footnotes."

Step 5: Assessing the Conclusion. The conclusion of an article is generally found in the last few paragraphs. Your first task here is to determine what conclusions the author has reached. Second, ask yourself whether they are convincing. Does the evidence presented in the main body of the article *prove* the conclusion? Or is the conclusion based on the speculations of the author? While there is nothing inherently wrong with a speculative conclusion, it is important for you to be able to identify it.

In the end, a good critique is really more about your own confidence as a reader than about possession of specific knowledge. And it usually takes some time to develop the necessary analytical skills. Possessing them, however, is not only important to your success as a student—understanding the structure of an article, identifying evidence and methodology, assessing the persuasiveness of an argument—these skills are also invaluable in the "real world," where you will be heading at some point.

6

What Do You Do with a Degree in Art History?

For most students, selecting a major is influenced not only by the love of a particular subject, but also by the reality of making a living. Few would deny that the popularity of undergraduate degrees in economics and chemistry, for example, is related, at least in part, to the lucrative careers that they lead to. But an art history degree? What do you do with that? Make lattes for the rest of your life? If that is what you think, this chapter will come as a pleasant surprise. The skills you learned as an art history major are comparable to those acquired in fields such as English, political science, sociology, and philosophy. The history of art, as the preceding chapters have hopefully made clear, is an analytical discipline, and thus prepares you for any job in which you are required to think critically, solve problems, build arguments, and write clearly and effectively. For these reasons, a B.A. in art history is excellent preparation for fields such as law and business, and many of my students have gone on to pursue careers in these areas.

But art history majors are equipped with special skills that others don't possess: they are taught to *see* critically and are endowed with a verbal command over the visual world—an all-important advantage in this day and age. The advantages of this kind of training become apparent, for

example, when traveling: while those who majored in biology might walk indifferently through a European capital or major museum, those with degrees in art history will enjoy recognizing and understanding works of art for the rest of their lives.

It is also possible to pursue a career that utilizes specifically your knowledge of the field. This chapter will explore the directions you can take with your degree. It will consider work in venues such as museums, auction houses, art galleries, and arts organizations, as well as freelance opportunities. Discussion will focus on the options available to those with *just* a B.A.; however, the final section will consider what you can do with an advanced degree in art history or with an art history bachelor's degree combined with degrees in law, business, or library science. You will learn about the responsibilities, special requirements, and the pros and cons of a variety of jobs. If you seek further information on any of the jobs listed, consult the listing of websites located at the end of each section. (Note, however, that due to the changeable nature of the internet, web addresses may change or become defunct.) For further general information on careers in art history see these websites:

> *www.arthistory.net/jobs.html*
>
> *http://www.indiana.edu/~aah/jobslink.html* (Association for Art History)
>
> *http://www.nd.edu/~crosenbe/jobs.html* (Career Alternatives for Art Historians)

MUSEUM WORK

If you are like most people, it is likely that you will have to get up each weekday morning, get out of bed, and go to work. However, imagine this scenario: while your friends trudge to a large office building downtown, your trip to work ends at a city museum, where you are surrounded by fascinating objects and people trained to work with them. One of the wonderful things about working in a museum is just this—the close proximity to works of art. Attending the opening night reception of an exhibit is of course another great perk!

Not surprisingly, the museum job market is competitive, and this is particularly true in large urban areas. Moreover, upper-level museum work, such as the job of curator requires an advanced degree in art history. There are, however, a variety of museum positions available to those with only a B.A., and once you prove yourself, you will be in a better

position to advance when the right opportunity arises. In most cases, moreover, your job will allow you privileged insights into the business of running a museum, from the "front end" of public exhibitions to work in fundraising, membership, education, public relations, exhibition installation, and retailing. The experiences gained and connections forged through these jobs often inspire newly minted B.A.'s to pursue advanced degrees in art history, and many will return to museum work as curators and directors.

Exhibition Installation. Did you ever wonder how museums create a distinctive "look" for their exhibits? Or why paintings are hung a certain way? If your interest tends toward the physical and mechanical, you might consider *exhibition installation.* On a given day, you might find yourself assisting in the hanging or lighting of works of art and aiding in the packing and unpacking of traveling art shows. Depending on the size of the institution, your responsibilities might also include hanging labels, captions, and posters (known as **wall text**), and framing art. Light construction is also sometimes required, such as building pedestals or repairing or painting gallery walls. These tasks will require some physical exertion on your part, so you should be in reasonably good shape. However, the job brings with it the excitement of actually *putting up* a show and the satisfaction of accompanying a work of art from packing boxes to public unveiling.

Public Relations. If you tend to be an extrovert and enjoy working with the public, the public relations department of a museum is an ideal venue for you. More than ever, it is crucial that museums support themselves by attracting membership and donors, and this is achieved in part by promoting awareness of the museum and its programs in the public sphere. Your responsibilities might include the printing and distribution of publicity materials and the creation of membership mailing lists (of both the postal and e-mail variety). Close contact with the public is also generally required; you might find yourself helping to plan public activities at the museum and coordinating these activities with other local organizations. And for those in public relations, attendance at exhibition openings is generally a must! In addition to having good communication and organizational skills, and a professional, pleasant manner with the public, computer graphics skills are also a plus.

Education and Outreach. Closely related to the field of public relations is museum education and outreach. This area is of crucial importance,

because most museums regard it as a mission to educate the public about their collections and programs. In the education department, you will work with a variety of sectors of the public, from all ages and all cultural backgrounds, from those who have only a casual awareness of what a museum is to those who are specialists. You might be asked to engage with underprivileged third graders or with a group of senior citizens visiting from out of state. Your responsibilities might also include cultivating relationships with schools and universities, organizing visits, helping to run evening courses for teachers, and creating study materials for school projects.

In museum education, creativity is often important to success. Imagine how exciting it is for 10-year-olds to walk through a gallery of paintings they don't understand! For this reason, museum educators often stage collaborative projects involving multidisciplinary activities like dance, music, and theater. This might mean, for example, staging role-playing and storytelling sessions, or planning museum-related games for both children and families.

Curatorial Assistance. If you are more interested in learning about and working closely with the objects themselves, you may consider the position of *curatorial assistant*. Responsibilities are extremely varied from institution to institution and, most likely, from day to day. An important aspect of the job, however, involves assistance with the preparation of written publications such as museum journals and **exhibition catalogues,** as well as captions and wall text. On a given day, you could be asked to hunt down a scholarly article, check a footnote for the museum catalogue, or conduct online research. You might also be asked to help with the preparation of loan agreements or coordinate travel arrangements for works of art or visiting speakers. Helping out at public events such as exhibition openings is often also part of the job. In any case, work on the curatorial staff allows you close contact not only with works of art, but it also gives you the opportunity to introduce them to the public.

Administration. For those who are detailed-oriented, and possess good writing and communication skills, another potential museum job can be found in administration. Typically, in museum work this is the closest approximation of an office job in the "real world." However, your duties will depend largely on the department to which you are assigned: if it is a small institution, you might find yourself working in many areas, from fundraising and business to assisting in the director's office. In general, however, your job will be to provide clerical and administrative support to museum staff and to assist in the day-to-day operations of the museum,

including answering phones, taking messages, and maintaining files. But you will also most likely have more specialized and interesting responsibilities. If you work in the acquisitions department of the museum, for example, you might be assigned to keeping track of recently purchased objects. In the case of more public positions, such as at the front desk, you would be responsible for providing general information to museum patrons in person and on the phone, answering questions regarding hours, directions to the museum, and calendar events.

Retailing and Reproductions. While the five positions listed previously are the most common avenues for art history undergraduates interested in museum work, other options also exist. For museums, an increasingly important source of revenue is produced by museum stores. Situated within the museums and in some cases also at branch locations, these stores specialize in selling museum publications and reproductions from the collection, including postcards and posters. Often, other goods not related to the museum but with particular historical or visual appeal will also be offered for sale. Work in museum retail essentially means working in a business within the museum. As such, duties include compiling the daily sales records for the registers, assisting with opening and closing procedures, managing sales, and training staff. You might also be involved with setting up retail displays and arranging merchandise. Intense daily contact with the public is part of the job. For further information the following list of websites will be helpful:

> *http://www.aam-us.org/* (American Association of Museums)
> *www.museumjobs.com*
> *www.museumwork.com* (Museum Resource Board)
> *http://www.globalmuseum.org/*
> *www.museum-employment.com* (Museum Employment Resource
> Center)
> *http://www.aam-us.org/aviso/index.cfm* (Aviso Employment
> Resources Online)

Getting Your Foot in the Door. If you have had no luck finding a museum job and are financially secure, you should consider volunteering or applying for a museum internship. Internships can be either paid or unpaid, and may involve a variety of responsibilities mentioned in the positions mentioned previously. They are excellent tools for networking and getting a better sense of the museum world. They also add a certain cache

to your resume. For a listing of museum internships, these websites will get you started:

www.museumjobs.com
www.museumwork.com (Museum Resource Board)
www.artjob.com

Alternatives to the Traditional Art Museum. As you conduct your job search, it would be wise to consider venues beyond just the museum of art—natural history museums, sports museums, museums of science and technology, and children's museums are also vital and exciting workplaces that can provide you with comparable experience. In addition, remember that museums come in all sizes. Working in smaller venues such as a university art gallery, historical house, or cultural center can also be particularly rewarding, often entailing more varied duties and more intimate work with the collections.

THE COMMERCIAL ART WORLD

The Art Gallery

Museum work, however, is only one of the routes you could take. Another way into the art world is through work in a gallery. In terms of environments, this venue offers some of the same advantages as a museum: close contact with works of art and the satisfaction of introducing those works to the public. However, the art market is far more volatile, and the fate of a commercial gallery is often decided by shifts in the economy and in public taste. However, there are certain advantages to working in a gallery. If it specializes in contemporary art, you may find yourself in working in an extremely trendy atmosphere, in close contact with artists, critics, and clients. Also, if you work as sales assistant and are very motivated, you have the opportunity make a great deal more money than those in an entry-level museum position. Finally, working your way to the top of a gallery does not require any advanced degrees. Many art dealers have only a B.A. in art history; they started work as gallery assistants and have advanced from there.

Your duties will vary with the type and size of the gallery. You might find yourself in the salesroom in close contact with the customers. Like any sales job, selling art requires an assertive personality; but it also requires a certain delicacy: customers like to be attended to but hate to be smothered.

It is also crucial that you have an intimate knowledge of the art in your gallery, and that you can convey this knowledge, and your excitement about the art, to potential buyers. I have a friend who has been extraordinarily successful in a commercial art gallery because of her infectious enthusiasm about the works.

While ringing up sales might be the most exhilarating aspect of the job, gallery assistants will generally also be asked to perform less glamorous duties, from clerical tasks, such as updating client databases, fielding phone calls, and keeping track of finances, to more mechanical activities, such as shipping, packing, and hanging. With experience, you might also be involved with planning displays and exhibitions, researching works of art, and writing or editing gallery catalogues. The advertisement and organization of gallery receptions is also generally part of the job. Good communication and networking skills, enthusiasm, and assertiveness are requisites for the gallery world, as is resilience in the face of market downturn. Knowledge of the type of art in which the gallery specializes—often contemporary art—is a plus. And if you find yourself working directly with artists, sensitivity to their needs is a must. Websites for those seeking jobs in the commercial art world abound, as the following list shows:

> *http://www.globalmuseum.org/*
> *www.arthistory.net/jobs.html*
> *www.Monstertrak.com*
> *http://oldwww.matrix.msu.edu/jobs/* (Job Guide for the Humanities and Social Sciences)
> *www.artjob.com*
> *www.artdealers.org/* (Art Dealers Association of America)
> *www.naadaa.org/* (National Antique and Art Dealers Association of America)

The Antique Market

Work in the antique market will require many of the same skills as an art gallery position: knowledge of the objects, assertiveness in sales, a good public manner, and the flexibility to perform a variety of duties. The same advantages exist, too: it is not necessary to have an advanced degree in order to reach the top position, which generally means having your own shop. Moreover, you will have the satisfaction of working closely with items of historical and aesthetic interest. While some dealers specialize in a particular type of object, others work with everything from paintings and

sculpture, to decorative art objects, such as furniture, jewelry, books, rugs, and clothing.

Generally, aspiring dealers start out as assistants in an antique gallery before running their own shop. As with a gallery owner, the antique dealer must have an intimate knowledge of the works they are selling. Good research skills are thus essential, and knowledge of a wide range of reference materials about maker's marks, imprints, the history of technology and design, as well as prints and drawings is particularly useful. And although the pressure is high to buy wisely, detective work of this kind is often cited as the most enjoyable and exciting part of the job.

Since it is necessary to invest a great deal of money in inventory, it is crucial for the dealer to get a return in the form of sales. For this reason, dealers need to be extremely familiar with the needs and preferences of their clients. If one runs a shop, excellent social skills are a plus, although personal charm is less important if you rent space in an antique mall or sell over the internet. In all cases, however, it is crucial to have excellent accounting and financial skills; some knowledge of tax laws is also useful. Antique dealers use the internet extensively. Here are some websites:

http://www.princetonreview.com/cte/profiles/dayInLife.asp?careerID=9
(a *Princeton Review* article on antiques dealers)

www.naadaa.org/ (National Antique and Art Dealers Association
of America)

The Auction House

Another popular arts-related career within the commercial sector is in the world of art auctions, and entry-level work generally requires only a B.A. As in the case of galleries, art is for sale, but in an auction house works are sold to the highest bidder rather than at a fixed price. The best-known institutions are Sotheby's and Christie's, based in London and New York, but with locations on the internet and in cities all over the world. In these houses, inventory can include everything from fine art to real estate to valuable wines. Moreover, both auction houses produce detailed catalogues that describe items for sale and their **provenance** (their history of ownership). Known both for the fame of the items described (such as "Old Master" paintings) as well as their high level of scholarship, these catalogues are more than just sales brochures; they are considered art-historical literature. Christie's produces over 800 such catalogues each year.

There are some significant perks to working in an auction house. As with museums and galleries, you will most likely gain hands-on experience

with various kinds of works. The prestige of working in the venerable auction houses, moreover, is almost equivalent to that of a major museum. There is also the excitement of working in a high stakes environment, in which a single item could sell for millions. And then there are the parties—auction houses make it a point to attract business through elaborate social engagements—and generally junior staff is invited!

Job responsibilities vary depending on the size of the auction house and the specific position held. One of the major tasks at the large houses is researching, organizing, and compiling the auction catalogues. And whatever department you work in, it is probable that you will be in contact with buyers and sellers. On a given day, for example, you might field phone calls from potential clients interested in selling their objects, arrange for evaluations by a resident expert, or prepare photographs for the catalogue.

In any case, from the moment the seller contacts the auction house to the mailing of final payments, the process requires a good deal of organization. And since much of the job is customer service, excellent people skills are a must. Depending on your specific position, business, marketing, and writing skills may be necessary. The main job requirement, however, is flexibility and versatility: you need to be able to jump from one sort of task to another. An ability to work under pressure is also important, particularly as deadlines for catalogue publications arrive.

If you want to get an inside track on an auction house job, or simply want a sense of what work in one is really like, you should consider interning. Christie's, Sotheby's, and other auction houses offers internships to college and graduate students who meet the requisite qualifications. The relevant websites are the following:

http://www.sothebys.com
http://www.christies.com
http://www.butterfields.com/ (Bonhams and Butterfield)

The Corporate Curator, Curatorial Consultant, and Arts Organization Consultant

In addition to traditional positions in the museum and commercial sector, three additional careers are also frequently taken by those with undergraduate degrees in art history: the corporate curator, curatorial consultant, and the arts organizational consultant. Although each entails different kinds of responsibilities, all require excellent analytical, communication, and managerial skills. None require an advanced degree in art history, but knowledge of **connoisseurship** (the attribution and appraisal of works of art) is important for positions as a corporate curator or curatorial consultant.

As the name implies, the *corporate curator* has much in common with the standard museum curator—both are in charge of developing and managing art collections. However, while the museum collection serves to preserve works of art and educate the public, the corporate collection is designed to communicate and enhance a company's image, and it often sets the tone for business transactions and meetings. At the same time, the collection should create a stimulating visual environment for employees. The corporate curator is responsible for forming and overseeing this collection. With the job comes tremendous responsibility; large corporations, for example, invest huge sums in building art collections and consider them major assets.

The responsibilities of the corporate curator are quite varied. If you are assigned to develop a new collection, your job will involve a great deal of research as you investigate potential works for purchase, assessing them not only for their appropriateness to the company, but also ensuring their authenticity. If you are dealing with an older collection, it may also be necessary to research the history of the existing works.

It is likely, moreover, that the process of selecting art will also involve members of the company's design department, prominent collectors among the executives, and certain members of the staff. For this reason, it is crucial that a corporate curator communicate effectively to those who are not art experts, without being patronizing or highhanded. The job also requires painstaking record-keeping. Acquiring new art, rotating exhibits, and merging collections (some of the most common tasks of the corporate curator) mean keeping a scrupulous database with files on each work, complete with all existing written and photographic documentation and research materials. Depending on the size of the company, it may also be necessary to have skills in exhibition installation.

The job of the *curatorial consultant* (or *freelance collection manager*) is similar to that of the museum and corporate curator. However, the former generally operate freelance rather than full time, hired to work on terminal rather than ongoing projects. A successful curatorial consultant is self-motivated and able to handle the inherent instability of the position. Many curatorial consultants, moreover, specialize in one particular art-historical field, such as Chicano art, and apply for projects in that area.

General duties vary tremendously with the nature of the specific project. Your work will most likely involve the acquisition, reproduction, installation, storage, and care of art, and you could be working for a historical society, a major museum, a private collection, or a cultural foundation. For example, as a field curator, you might be assigned with the decoration of a historical house, collecting all fine art and furnishings, restoring these objects, and installing them on site. One curatorial consultant procured

more than 700 artifacts for a Mexican museum. Another worked with a museum staff to plan an exhibit commemorating the completion of the Alaska Pipeline, reviewing archive materials to identify themes and choose display objects, conceiving the general lines of the exhibit, and composing text and captions.

Excellent social and communication skills are a must, as the job entails substantial involvement with people. You will most likely be asked to interact with other art professionals as well as members of the public. It is also crucial that you are comfortable with giving presentations, as it is likely that you will be required to pitch ideas to potential employers or staff. Superior organization skills and attention to detail, particularly regarding record-keeping, are also important. In some cases, experience with exhibition installation may also be required.

Both the curatorial and the *arts organization consultant* need to be comfortable with instability, able to interact with a wide variety of people, and be adept at problem solving. However, while the primary goal of the curatorial consultant is to assist in an art-related project such as an exhibit or collection, the arts organization consultant works with an arts institution, helping to improve or change it in some way. Familiarity with legal and political issues and good writing skills are essential. And because the position more closely resembles that of a traditional consultant in the business world, business skills are essential. In fact, some arts organization consultants have M.B.A.'s. However, a master's degree in business is not considered a requirement to operate in the field.

The specific responsibilities of the arts organization consultant will vary according to circumstance. The key job of the consultant, however, is to provide artistic, organizational, and development advice. In the case of the Montana-based Myrna Loy Center, dedicated to the film actress by the same name, the consultant assessed the structure of the organization and made recommendations for improvements in its governance, staff, fiscal operations, business systems, and programs.

For information regarding the positions of corporate curator, curatorial consultant, or arts organization consultant see the website *www.artjob.com*

THE PUBLISHING WORLD

In art history class, did you find that your excitement peaked at the process of *reading and writing about art?* If so, you might be well matched to a career in art publishing. The production of art books, magazines, and newspapers is a large and vigorous business, and entry positions require

only a B.A. to start. Although the work can be grueling, sticking it out often means advancing from the position of editorial assistant to assistant editor, then associate editor and senior editor, and then on to a top editorial position such as editor-in-chief or executive editor. At the highest level, editors enjoy seeing their creative vision come to life, earn six-figure salaries, and keep company with the glitterati of the art and literary worlds. Even for the lowly editorial assistant, however, benefits include the satisfaction of producing a concrete product, proximity to interesting (if not eccentric) people, and *free books.*

So what precisely does an editorial assistant do? Much depends on the type of publishing company and the type of work produced. However, assistants often find themselves proofreading, fact-checking, and conducting some research, whether bibliographic (hunting down books and journals) or visual (searching for and researching images). There are also clerical aspects of the job, such as answering phones and mail, setting appointments, and writing letters for an editor or editors. You may also be assigned to read, assess, and summarize manuscripts for your editor. Although pay can be low and hours long, most assistants are promoted after about two years to assistant editor. Skills for the job include excellent writing skills, the ability to summarize, and meticulous work habits. Experience in editing (for your college newspaper or yearbook) is also a plus. But if one had to name the most important prerequisite to a career in publishing, it is the love of reading. If you enjoy spending weekends with your nose in a book, this may be the job for you.

As with the jobs listed above, another option is to intern at a publishing company in order to network and learn about the business. Entering through a temporary employment agency is another way in. In any case, competition is rather stiff in this field, and having the right contacts is important to success. These websites will help you find further information:

http://publishing.about.com/cs/careers/

http://www.publishers.org/careers/jobs.cfm (Association of American Publishers)

Alternative Careers in Writing

In addition to the careers mentioned previously, there are other career paths also appropriate for students with art history degrees. One of the most common is freelance art writer. As with the curatorial and arts organizational consultant, the freelance writer must be self-motivated and tolerant

of instability. A B.A. in art history is all that is necessary, although advanced degrees might open some doors.

It is difficult to generalize about the work of a freelance art writer. You might find yourself writing about Ajanta cave paintings for *arthistoryabout.com,* or critiquing a recent exhibit for a local newspaper or magazine, or acting as a monthly correspondent for an art journal, or working as a travel writer, visiting exotic locales or foreign museums and publishing your observations. You might be assigned to specific tasks such as writing or editing, or be placed in charge of entire projects from initial research to proofreading and supplying illustrations. Or you could write the art-related sections of travel publications. Many writers, moreover, combine their career with curating, lecturing, editing, and giving tours. Some are also gallery owners or artists themselves. While some senior writers specialize in particular types of art or literary genres, it is best for newcomers to be as versatile and adaptable as possible. Opportunities are grabbed by the most assertive and the best-connected, so ferocious networking is a critical part of the job, both in obtaining assignments and marketing your work. It is wise to join many different organizations related to writing, journalism, and art-related fields, and to attend meetings whenever possible. Online writers' discussion groups are also very useful for making contacts. The more editors and writers you meet, the better are your chances to get assignments. Try these websites for further information:

http://www.poewar.com/ (Writers' Resource Center)
www.WritersWeekly.com

THE ARTS AGENCY

Working at the National Level

Another career avenue is through work in national, state, and local arts agencies. At the national level, the most prominent organizations include the National Endowment for the Arts (NEA), National Endowment for the Humanities (NEH), and the Archives of American Art. The aims of the NEA, an independent agency of the federal government, are (as their mission statement announces) "to provide national recognition and support to significant projects of artistic excellence, thus preserving and enhancing our nation's diverse cultural heritage." The agency promotes participation in and access to a wide range of arts and cultural activities, promoting excellence in these endeavors. It also makes decisions on policy and funding matters for the development of the arts in the United States.

Entry level work at the NEA requires only a B.A.; however, advanced degrees might be appropriate depending on the position. The organization is made up of diverse departments, including those dealing with administrative services, dance, music, theatre, folk and traditional (or native) arts, communications, public policy, grants and awards, development, and contracts. At the higher levels, positions include those of speechwriter, program analyst, specialist (in music, dance, theatre, etc.), and congressional and White House liaison. Another position within the institution is that of the *arts learning specialist,* who fosters relations between the NEA arts education program (known as the Arts Learning Program) and state agencies. As a freshly minted college graduate, it is most likely that you will be responsible for assisting in one of the departments. Depending on the position, your job may involve research, interaction with people, and some writing. As with any governmental position, political skills are also useful.

Internships are available at the NEA, and generally involve assisting the staff in the process of awarding of federal grants. This is a wonderful way to make contacts and get a leg up on the competition for a paid position. You will also have access to an excellent art library. Further information can be obtained at these websites:

http://arts.endow.gov/ (National Endowment for the Arts)

http://www.neh.gov/ (National Endowment for the Humanities)

Working at the State and Local Level

Working at a national arts organization may entail relocating to Washington, D.C. However, if you wish to start locally, there are numerous state and local agencies to consider, both governmentally and privately sponsored. Although they do not offer high salaries, these organizations are excellent venues for networking. They are designed to serve community artists, arts teachers, and the public at large through a variety of programs and services. The Maine Arts Commission, for example, supports school arts programs, individual artists, tourism related to the arts and historical heritage, and apprenticeships in traditional (or native) arts.

Your duties could span a very wide range, from work in marketing and public relations to grant writing. You might be involved in planning local festivals and shows, working in an underprivileged community, or assisting in a tour of local historical sites. The schedule might also be erratic: some arts agency workers are hired only for a short term and working an

occasional weekend or late night is also often required. Those suited to this environment are self-motivated, possess excellent verbal and written communication skills, and are competent with computers (particularly as used for desktop publishing). A valid driver's license is also a plus. Contact *www.nasaa-arts.org/* (National Assembly of State Arts Agencies) or *www.artjob.com* for further information.

AND IF YOU DECIDE TO GET AN ADVANCED DEGREE . . .

As the previous section attests, there are numerous jobs for those with only an undergraduate degree in art history. However, the options become more numerous and the responsibilities greater if you also possess an advanced degree, either in art history or in another related field. The following careers, which range from art investor to visual resources curator, are some of the most commonly pursued.

Art Librarian. The position of art librarian typically requires an M.A. in art history as well as a Master of Library Sciences (M.L.S.). Foreign languages (particularly French and German) are also important. The job also necessitates excellent skills in research, verbal and written communication, administration and management, and computer technology. Most art librarians work in a college or university setting, maintaining and expanding collections of printed and electronic resources, and assisting staff, students, faculty, and sometimes the public. Specific responsibilities often involve helping students locate bibliographic materials, answering telephone and written inquiries, issuing books, and in some cases, doing the reshelving of library materials. In addition to such services, the art librarian also selects and acquires books, exhibition catalogues, and journals, and then classifies, catalogues, and binds them. At the higher levels, responsibilities also include establishing the library's collection development policy and, in many recent cases, undertaking the conversion of catalogues from print to digital form. Related careers include archive manager and art reference librarian, both of which are also involved with managing collections and serving the needs of scholars and other clients. Websites of interest to potential art librarians can be found at the following:

> *http://www.arlisna.org* (Art Libraries Society of North America)
> *http://www.ala.org/* (American Library Society)
> *http://www.collegeart.org/* (College Art Association)

Visual Resources Curator. As with the position of art librarian, that of *visual resources curator* also typically requires an M.A. in art history. An M.L.S. is also desirable, but not necessary. Depending on the position, French, German, or other languages may be required. The position is generally situated within an academic environment such as a university, and most curators manage slide collections within departments of art and art history. However, visual resource collections also exist in research institutes, museums, historical societies, archives, public libraries, governmental agencies, and corporations. Necessary skills are also comparable to that of an art librarian: the ability to interact well with people, undertake research, manage staff, and work with "analog" technologies such as photography and slide projection, as well as with the latest relevant computer programs. The best visual resource curators are extremely knowledgeable about art history, and can respond to random queries such as "I am thinking of a nineteenth-century painting with a basket of oranges in it. Do you know the one, and do we have a slide of it?"

Duties include the creation, development, and management of collections of a wide range of visual materials including slides, photographs, and, increasingly, digital images. In an academic institution, the visual resources curator will support both faculty and students, and often interact with the school libraries. The job also often entails supervising staff members and multiple student assistants, and providing for the projection needs of the art and art history departments.

Some additional information can be found at these websites:

http://www.vraweb.org/ (Visual Resource Association)
http://www.chatham.edu/users/staff/dnolting/ (Visual Resources
 Division of the Art Libraries Society of North America)
http://www.collegeart.org/ (College Art Association)

Art Appraiser. Unlike the prior two positions, the *art appraiser* generally operates in the commercial art world, and is hired to assess and authenticate works of fine and decorative art. A certificate in appraisal studies is typically required (see websites below). The job requires knowledge of IRS and other tax laws, excellent research skills, and close familiarity with online and printed bibliographic materials concerning the history of art, technology, design, and prints and drawings. More specialized subject knowledge may also be necessary depending on the position.

Excellent communication skills are also critical, as the job entails close involvement with a wide range of people, including trust officers,

antique dealers, artists, and sometimes the family members of the deceased artist or collector. In addition, appraisers work with collectors seeking to secure their investment, insurance agents seeking customer appraisals, and artists wishing to fix selling prices. Appraisers might focus on single items at an auction, helping to establish selling prices and instructing potential buyers on how much to bid. Or they may deal with entire collections, as is often the case in estate and divorce evaluations.

Websites relevant to art appraisers include:

http://www.isa-appraisers.org/ (International Society of Appraisers)

www.appraisers.org/ (American Society of Appraisers)

http://www.appraisersassoc.org/ (Appraisers Association of America)

Art Investor/Advisor. Another career opportunity in the commercial art world is the position of *art investor.* Typically, investors possess a B.A. in art history, a Bachelor of Business Arts (B.B.A.), or a Master of Business Arts (M.B.A.). Some also have an M.A. in art history. The job entails good skills in research, business and investment, connoisseurship, and communication. A familiarity with technology, and particularly financial software programs is also useful.

The responsibilities of the art investor are varied, and some specialize in particular fields and categories of art. Generally, however, the job involves analyzing trends in the art market and advising clients on purchasing decisions. Interaction with all types of people and organizations is a consistent feature of the job; an art investor will consult with private collectors, museum and corporate curators, decorators, and artists, and will foster close links with art galleries, centers, and institutions. The successful investor will simplify the process of selecting investment art by presenting the client with appropriate work, and by effectively and objectively conveying its worth.

Additional information can be found on these websites:

http://dcwi.com/~dave/aim.html (*Art Investor Magazine*—an e-zine on art investing)

www.art-investor.de/ (a German site worth reading in English translation)

Art Law. So perhaps you have decided to sell out and go to law school. This does not mean you must forsake an arts-related career! If you want the high salary and prestige of a legal career but crave contact with art and artists, then you should consider the growing field of art law. The position

generally requires a B.A. or M.A. in art history and a law degree. Several universities offer special programs in art law. As with the job of art investor, an art lawyer typically possesses good research, business, and communication skills.

Art lawyers provide representation to individual artists and entertainers as well as to museums, arts organizations, and entertainment companies. They often attend to issues of intellectual property, entertainment law, art fraud, and art theft. They handle cases involving claims of copyright infringement, trademark rights and development, and entertainment licensing. Often they handle contract negotiations for artists and entertainers. Art lawyers also act as courtroom representatives and aid in the selection of expert witnesses, particularly in cases involving stolen art.

The website *www.abanet.org/careercounsel/students.html* (American Bar Association) will provide information on careers in art law.

Art Conservationist. Of all the arts careers, that of *art conservator* is probably the most "hands-on" of all: it involves the preservation and restoration of works of fine and decorative art. Conservators typically possess an M.A. or Ph.D. in art history with a specialization in conservation. A strong background in the sciences, particularly chemistry and physics, is essential, as is experience with laboratory and studio techniques. Good research skills are also critical to success.

Arts conservators work both in institutional settings and in private practices, and often specialize in a particular category of art, such as furniture or works on paper. Work might be undertaken in the studio or on site, in private homes, storage warehouses, exhibition spaces of galleries and museums, and public buildings. Responsibilities are varied. On a given day, a conservator might engage in the following activities: examining a work to determine what kind of materials and technique were used, performing the necessary conservation or restoration treatment to insure conservation, interacting and negotiating with clients, potential clients, and artists, conducting research to keep up with new techniques, and writing a report of actions taken.

For further information on careers in art conservation, see the following websites:

http://aic.stanford.edu/ (American Institute for Conservation)
http://palimpsest.stanford.edu/ (Conservation Online)

High School or Community College Instructor. Typically, teaching positions in art history are occupied by those with Ph.D.'s. However, in the

case of community colleges, two-year colleges, and private high schools, teacher with master's degrees in art history are also often considered.

Keep in mind that you will face competition from applicants who hold a Ph.D., so perseverance is necessary. Teaching experience is generally a requirement. A love of the profession is also necessary. At the institutions mentioned above, the focus is on student instruction rather than scholarly research. In some cases, you will teach many courses, and if you are new to teaching, class preparation will be time-consuming and tiring. Also, it is best to locate a position that is full-time rather than adjunct. Full-time instructors typically get paid a salary and receive benefits; adjunct professors, on the other hand, often receive no benefits and are paid by the course, which often amounts to extremely low paychecks. However, adjunct professors are generally not required to perform institutional service, such participating in campus committees, attending faculty meetings, and doing the sundry administrative work generally requested of permanent staff.

Websites that offer information on careers in teaching art history follow:

http://www.collegeart.org/ (College Art Association)
www.chronicle.org (*Chronicle of Higher Education*)

Museum Work at the M.A. and Ph.D. Level. As mentioned in an earlier section of this chapter, an M.A. or Ph.D. in art history will grant you access to higher-level museum positions than a B.A. Although you could find yourself in a variety of departments, your work will entail increased responsibilities and independent work. The position of curator (most often requiring a Ph.D.) or assistant curator requires intensive research, and the ability to read in foreign languages, frequently in French, German, and Italian. Writing skills are also crucial; it is the job of the curatorial staff to write and edit museum catalogues. The curator will also make decisions regarding the acquisition of new works of art, and he or she must conceive of and supervise exhibits. As much of the job involves interaction with people, excellent communication skills are a must.

College and University Teaching. If you are reading this, you must be serious about art history! Teaching at the college and university level generally requires a Ph.D. Those who have earned their doctorate possess extensive experience in research and writing from completing their *doctoral dissertation,* a research document which in art history generally numbers no less than 200 pages. Doctorate holders also have training in foreign

languages such as German, French, and Italian. Those successful in locating a full-time university position also possess teaching experience, gained either during stints as an adjunct instructor or as a teaching assistant while in graduate school. Written publications are also important: books with good university presses and articles in prestigious journals are the most attractive, but any evidence of published work is helpful, including proceedings from conferences, catalogue entries, and book reviews.

Unlike those with a job as community college instructor, most full-time professors are granted more time for research. In fact, it is crucial to conduct research and write while teaching, as an active scholarly record is a cornerstone for receiving tenure, which virtually ensures your position for as long as you wish it. In addition to teaching and research, your work at the university will also involve additional service, such as acting as department library liaison or graduate advisor. Information about teaching art history at the university level can be found at the following websites:

http://www.collegeart.org/ (College Art Association)
www.chronicle.org (*Chronicle of Higher Education*)

A Final Word of Encouragement

All the positions listed previously require you to be persistent and willing to work hard. Network as much as possible. Be patient if opportunities do not arise immediately. And don't lose sight of what you attracted you to art history in the first place. Remember, success in any career, whether as a dentist, corporate executive, or cowboy, requires some struggle. Why not struggle for your career surrounded by art and artists?

Glossary

Abstract *Abstract* art refers to works that originate in the mind of the artist, rather than being inspired by the visible world. Thus, it is **nonrepresentational** art.

Abstract Expressionism Also known as the New York School. A school of painting and sculpture active in New York between c.1940 and c.1960, including artists such as Arshile Gorky, Mark Rothko, and Jackson Pollock. Abstract Expressionists sought to convey universal themes through abstract rather than naturalistic means. In painting, many abandoned the idea of the canvas as an illusionistic window onto another space and emphasized instead the surface plane of the work itself.

Abstraction The process of *abstraction* refers to the reduction of naturalistic forms to patterns and shapes invented by the artist.

Academic abstract The summary of a larger academic work.

Acanthus A type of ornament inspired by the long, spiky leaves of the Mediterranean plant known as the acanthus, and often represented on classical and medieval sculpture, as seen, for example, on Corinthian *capitals*.

Apse A semicircular wall, used often in Roman and medieval architecture. In church architecture, apses are generally placed at the east end of the building and are used for the celebration of the mass.

Archivolt In architecture, the arched molding surrounding a semicircular *portal* or window. The portals of medieval churches are often framed by a series of archivolts embellished with sculpture.

Basilica A longitudinal building in which the central aisle (or *nave*) is elevated and pierced with a *clerestory*. Basilicas were commonly used in Roman and early Christian church architecture.

Biomorphic Forms that represent living beings such as humans, animals, and plants.

Capital In classical architecture, a sculpted element capping a column. Three of the most common types of capitals are Doric, Ionic, and Corinthian.

Centralized structures Generally round, polygonal, or lobed structures in which the focus is directed on the center of the interior space.

Chiaroscuro In Italian, literally "light-dark." A pictorial effect in which volume is conveyed through the contrast of light and dark.

Chronology The record and measurement of time. In art history, the term is often used in reference to dating works of art.

Composition The arrangement and organization of forms in a work of art.

Connoisseurship The study of the visual properties of a work in order to identify its origins and assess its worth.

Content The subject matter of a work of art.

Context The circumstances in which a work was produced. Among the different categories of context are *historical* context, which refers to the events that occurred at the time in which the work was produced; *physical* context, the work's physical surroundings; *social* context, the gender or class issues which informed a particular work; and *political* context, the dominant political ideas which may have influenced it.

Contour line The outline defining the perimeter of a shape.

Contrapposto In figural sculpture, a pose in which one leg is shown straight and bearing weight while the other is resting and bent at the knee. In this position, the figure's hips and shoulders are also slightly tilted.

Critical anthologies A book of essays written by various scholars in which they consider different aspects or examples of a single theme.

Critique The evaluation of a work of scholarship.

Cross-section A way of diagramming architecture in which the building is cut away from top to bottom, allowing us to see elements such as the relative heights of the walls and the profile of the rooflines.

Cutaway drawings Architectural renderings in which both the interior and exterior of a building are revealed.

Description essay A short art history paper generally of no more than five pages in which a single work of art is thoroughly described. Also referred to as a *response paper.*

Diminution A pictorial system in which depth is conveyed by rendering figures in the distance as increasingly smaller in scale.

Drapery The loose, togalike clothing worn in the classical and medieval eras.

Entablature In Greek and Roman architecture, all the horizontal elements which rest on the columns and capitals.

Exedrae In architecture, a series of columns arranged in a semicircle.

Exhibition catalogue The publication accompanying a museum exhibit often written by a team of writers, which includes introductory essays and descriptions, photographs, and a bibliography of the works displayed.

Exhibition installation The process of setting up an exhibition, from unpacking works of art to building pedestals, arranging lighting, framing, and the final display.

Expressionism An artistic style which appeals to the emotions of the viewer, often in an exaggerated or theatrical way.

Feminism In art-historical methodology, an approach that explores the perspectives of women as viewers, subjects, and artists.

Figure In art-historical parlance, the representation of the body.

Form The visual elements of a work of art.

Formal analysis The practice of describing the formal elements of the work and analyzing how they create a particular effect.

Formalism An art historical method focused on the formal elements of a work.

GIF Group Interchange Format. A method of storing digital images. See also *JPEG*.

Ground plan A method of rendering a building that reveals its spatial layout. In a ground plan, it is as though the building has been sliced away at its base, and you are looking at it directly from above.

Hatching In drawing, short sharp strokes, often used to indicate *volume*.

Iconography The study of the subject matter of art and its symbolic content.

Idealism A standard of visual perfection or beauty, as determined by a specific culture.

JPEG Joint Photographic Expert Group. A method of storing digital images. See also *GIF.*

Linear A style of depiction in which lines are the primary element.

Macrostatement In art history lectures, a broad generalization regarding the typical characteristics of a period or style.

Marxism In art-historical scholarship, an approach that focuses on the circumstances in which a work was produced and paid for.

Medium The category to which a work of art belongs. The three main *media* are architecture, painting, and sculpture. Other media include digital art, collage (referred to as mixed media), and earthworks.

Methodology In scholarship, the way in which a problem or issue is handled.

Modeling In two-dimensional art, a technique in which shadow is applied to a form to indicate *volume.*

Naturalism A mode of artistic representation inspired by the way forms appear in nature. In a *naturalistic* work, for example, forms such as humans, trees, and plants seem lifelike. See also *abstraction* and *realism.*

Negative shapes The absence of solids, or the voids, located around and between solid shapes.

Nonrepresentational (or nonobjective art) A mode of representation consisting of *abstract,* rather than *naturalistic* forms.

Orthogonals In two-dimensional images using *perspective,* the diagonal lines that recede to the *vanishing point* or points.

Painterly A style of painting in which the action of the brushstrokes and paint texture are clearly discernible.

Palette A flat, rounded surface held in the hand and used for mixing paints. In ancient Egypt, palettes were used to mix cosmetics. The term also refers to the range of colors used by a particular artist or in a specific work.

Peer-reviewed journal In art-historical scholarship, a periodical in which potential articles are reviewed by experts prior to acceptance for publication.

Perspective A pictorial system used to indicate depth in two-dimensional works. Among the most common forms of perspective are the following: *atmospheric perspective,* in which objects meant to be understood as farther from the viewer are depicted with increasingly fading color and fuzzier outline. *Intuitive perspective* is based on the intuition or sensation of depth rather than on a scientific system. *Scientific perspective* refers to the Renaissance invention in which depth is conveyed through the use of diagonal lines, or *orthogonals,* which recede back to a single *vanishing point* on the horizon line. In the case of *vertical perspective,* objects meant to appear at a distance are placed increasingly higher.

Pictorial depth The recession of space into the distance, as created in two-dimensional art.

Portal The main doors of a structure (usually a church), often embellished with decoration and used in ceremonial events.

Primary sources In art-historical scholarship, the subject of study, whether the works of art themselves or related documents. For example, for a study of the

artist Jacopo Tintoretto, both his paintings and his diary constitute primary sources.

Provenance The history of the ownership of a work of art, from the time when it was first produced to the present day.

Realism A mode of artistic representation in which the artist carefully records forms in order to capture them precisely as they are in real life. In a work of realism, for example, human figures appear "warts and all," with wrinkles, irregularities, and asymmetries.

Reliquary The container for *relics,* the physical remains of a holy person or thing. Reliquaries were produced in great numbers during the Middle Ages; those that survive are often of composed of precious materials.

Response essay See *description essay.*

Scale The size of a work of art, often in relation to the viewer or another object.

Secondary source In art-historical scholarship, secondary sources refer to what scholars and critics have said *about a subject.*

Shape The physical contours of a work of art.

Space The negative shapes or voids in a work of art.

Style The artistic mode in which a work of art is rendered. *Realism, naturalism, idealism,* and *abstraction* are four of the most common styles.

Thesis statement In art-historical scholarship, a brief statement of the author's argument generally located in the introduction.

Triumphal arch In Roman architecture, a grand, freestanding arch often used in triumphal processions and decorated with elaborate sculpture. In early Christian architecture, the arch is an interior feature, located directly in front of the *apse.*

Vanishing point In a two-dimensional image using perspective, the point on the horizon line at which the *orthogonal* lines intersect. In works using *scientific perspective,* only one vanishing point appears. In *intuitive perspective,* often several appear.

Visual literacy The ability to "read" images and to understand and discuss the elements that give them power.

Vital statistics In art history, the title, artist, date, period, and location of a work of art.

Volume The illusion of roundness, particularly as created in two-dimensional art through *hatching* or *modeling.*

Wall text Any texts, such as captions, maps, and posters that appear on a museum wall as part of an exhibit.

Index

Page numbers in italics refer to illustrations

A

Abbey of St.-Denis, 8
Abstract expressionism, 63
Abstract style, 40, 58, 62
Academic abstracts, 102
Acanthus leaves, 58, *59*
Architecture:
 classroom presentations of, 7–9
 comparisons and, 30–31
 line in, 44–45
 location and, 16
Archives of American Art, 138
Archivolts, 53
Arch of Constantine, 49, *49*
Art Abstracts, 102, 103–5
ART-Bibliographies MODERN, 103
Art Bulletin, 108
Art-historical publications, 100–102
Art history:
 careers in, 126–45

classroom:
 layout of, 6
 lectures, 9–23
 presentation of visual information
 in, 7–9
courses, misconceptions
 about, 3–4
exams, 71–96
research projects, 97–125
response essays, 33–70
value of, 1–3
Art History (journal), 108
Art History (Stokstad), 99
*Art Information: Research Methods and
 Resources* (Jones), 111
Artist identification, on art history
 exams, 74
Arts agencies, art history careers in,
 138–40
*Arts and Humanities Citation
 Index,* 103

Atmospheric perspective, 52
Augustus of Primaporta, 16–17, *17,* 81
Avery Index to Architectural Periodicals,
 103, 105–7, 108

B

Background, 50
Baptism of St. John the Baptist,
 The (Pisano), 26
Barnet, Sylvan, 34
Bathers, The (Renoir), *28,* 28–31, 38, 55,
 58, 82
Bernini, Giovanni Lorenzo, 16
Bibliography of the History of Art, 102
Biomorphic shapes, 48
Brueghel, Peter, the Elder, 42–43, 79–80
Burlington Magazine, The, 108

C

Campin, Robert, 17
Caracalla, 58, *59*
Careers in art history, 126–45
 art appraiser, 141–42
 art conservationist, 143
 art investor/advisor, 142
 art law, 142–43
 art librarian, 140
 arts agency, 138–40
 national level, 138–39
 state and local level, 139–40
 college and university teaching,
 144–45
 commercial art world, 131–36
 antique market, 132–33
 art gallery, 131–32
 arts organization consultant,
 134, 136
 auction house, 133–34
 corporate curator, 134, 135
 curatorial consultant, 134,
 135–36
 high school or community college
 instructor, 143–44
 museum work, 127–31
 administration, 129–30

 curatorial assistance, 129
 education and outreach, 128–29
 exhibition installation, 128
 internships and, 130–31
 at M.A. and Ph.D. level, 144–45
 public relations, 128
 retailing and reproductions, 130
 publishing world, 136–38
 visual resources curator, 141
Centralized structures, 30
Charlemagne, 11
Chartres Cathedral, central tympanum,
 21–23, *22,* 53, 82–85
Chiaroscuro, 56
Chicago Manual of Style citation
 guidelines, 119–20
Chronology, 12–13
 guide to, 13–16
Cityscape, 51, 52
Color, 57
Columbia Guide to Online Style
 (Walker & Taylor, eds.), 120
Commercial art world, art history:
 careers in, 131–36
Comparisons, 21–23
 note-taking on, 28–31
Compositions, 44, 53–54
Composition with Red, Blue, and
 Yellow (Mondrian), 42, *45,*
 47, 62
Connoisseurship, 134
Contemporary, as art history term, 16
Content, in art history lectures, 16–18
Context:
 historical, 9–12
 methodologies and, 123
 original, 41
Corinthian capital, 58–59, *60*
Critique, 120
Cross-section, 8
Cutaway drawings, 8

D

Dates, on art history exams, 74–75
David, Jean-Louis, 12, 58
Day at the Races (Degas), 11

Demoiselles d'Avignon, Les (Picasso),
28–31, *29,* 57, 82–83
Description essays. *See* Response
essays
*Dictionary of Subjects and Symbols in
Art* (Hall), 111
Diminution, 52
Doryphoros (Polykleitos of Argos), 7, *8,*
16, 59–61, 92–93
Drapery, 19

E

Ebbo Gospels, 47, 47–48, 58, 62
Ecstasy of St. Theresa (Bernini), 16
Entablature, 45
Essay, art history exam and, 73
Exams, art history:
basic parts of:
essay question, 89–94
slide comparisons, 80–89
slide identifications, 72, 73–80
overview, 71–72
unknowns on, 94–95
Exedrae, 31
Exhibition catalogues, 129
Expressionism, 62, *63,* 82

F

Feminism, as methodology, 123
Figures, 19
Fleming, John, 110
Foreground, 50
Formal analysis, in art history lectures,
20–21
Formalism, as methodology, 122–23
Forms, 16
evolution of, 23

G

Gehry, Frank, 42
Gislibertus, *82*
Ground plan, 7
Grove Dictionary of Art, 107–8

H

Hall, James, 111
*HarperCollins Dictionary of Art Terms
and Techniques, The*
(Mayer & Sheehan), 111
Hatching, 45
Historical context, 9–12
Honour, Hugh, 110
Hue, 57

I

Iconography, as methodology, 123
Idealism, 58, 60–61
Ingres, Jean-Auguste-Dominique, 18, 58
Intensity, of color, 57
Internet, 98–109
finding images on, 99–100
finding scholarly work on,
100–109
Intuitive perspective, 52

J

Jones, Lois Swan, 111

K

Khafre, 38, *39,* 81

L

Large Odalisque (Ingres), 18, *19,* 58
Last Judgement, Autun Cathedral
(Gislibertus), 22–23, *23,*
82–85
Lectures, art history:
historical background/contextual
information in, 9–12
note-taking in, 23–32
visual information in, 12–23
comparison and, 21–23
content and, 16–18
formal analysis and, 20–21
macrostatement and, 21

Lectures, art history: *(contd.)*
 visual description and, 18–20
 vital statistics and, 12–16
Light, 55–57
Line, 41–48
Linear style, 58
Local colors, 57
Locations, on art history exam, 74
Looking and Writing (Wyman), 117

M

Macrostatement, 21, 30, 31
Mankaure and his Wife, Queen
 Khamerernebty:
 exam essay on, 91–92
Marxism, as methodology, 123
Masaccio, 43
Materials identification, on art history
 exams, 75
Mayer, Ralph, 111
Medium, 38
 identification, on art history
 exams, 75
Menkaure and his Wife, Queen
 Khamerernebty:
 response essay for, 61, *61*
Merode Altarpiece (Campin), 17, *18*
Methodology, 122–23
Middle ground, 50
Modeling, 48, 82
Modern Language Association (MLA):
 citation guidelines, 117–19
Mondrian, Piet, 42, 62
Monet, Claude, 7, 57
Movement identifications, on art history
 exams, 75
Museum of Contemporary Art, Bilbao,
 Spain (Gehry), 48, *48*
Museums, art history careers
 in, 127–31

N

Nana Ziggurat, 8–9
National Endowment for the Arts
 (NEA), 138

National Endowment for the Humanities
 (NEH), 138
Naturalism, 58–60, 82
Negative shapes, 49
Nike of Samothrace, 19, *20, 42*
Nonrepresentational/nonobjective style,
 58, 62
Note-taking:
 in art history classes, 23–32
 comparisons and, 28–32
 overview, 23–25
 page organization, 25–27
 for research projects, 111–15

O

Oath of the Horatii (David), 12, *13,*
 44, 51
Original context, 41
Orthogonals, 52
Overlapping, 52

P

Page Depicting Mark the Evangelist, 47,
 47–48, 58
Painterly style, 58, 82
Palette, 10
 of colors, 57
Palette of Narner, The, 10
Parthenon, 44–45, *46*
Peer-reviewed journals, 104
Penguin Dictionary of Architecture
 (Fleming, Honour, &
 Pevsner), 110
Period identifications, on art history
 exams, 75
Pevsner, Nikolaus, 110
Picasso, Pablo, 28, 57, 82–83
Pictorial depth, 50–52
Pisano, Andrea, 25
Pollock, Jackson, 63
Polykleitos of Argos, 7
Portal, 21
Positive shapes, 49
Prewriting, for response
 essays, 38–41

Primary sources, 122
Publishing, art history careers
 in, 136–38

R

Raising of the Cross, The (Rubens),
 54, *55*
Realism, 58
Reliquary of Einhard, 11
Renoir, Pierre-Auguste, 28, 82
Repentant Magdalen (Tour), *56,*
 56–57
Representational style, 58
Research projects, 97–125
 analyzing scholarship, 120–25
 formulating citations, 117–20
 internet research, 99–109
 finding images, 99–100
 finding scholarly work,
 100–109
 library visit, 110–15
 research paper, tips for writing,
 115–17
 topic formulation, 98
Response essays, 33–70
 choosing work of art for,
 36–37
 formal elements, analysis of,
 41–64
 color, 57
 composition, 53–54
 light, 55–57
 line, 41–48
 relative scale, 53–54
 shape, 48
 space, 49–52
 style, 58–64
 museum/gallery experience and,
 35–36
 overview, 33–34
 prewriting for, 38–41
 recording impressions for,
 37–41
 writing guidelines, 64–70
 for conclusion, 68–69
 for introduction, 65–66
 for main body, 66–68

Return of the Hunters (Brueghel the
 Elder), 42, *46,* 79–80
Robie House (Wright), 16

S

Sayre, Henry, 34, 37, 117
Scale, 53–54
Scientific perspective, 52
Scream, The (Munch), 62, *63*
Secondary sources, 122
Shape, 48
Sheehan, Steven, 111
Short-answer identifications, on art
 history exams, 78–80
Short Guide to Writing about Art, A
 (Barnet), 34
Slide comparisons, on art history exams,
 72, 80–89
Slide identifications, on art history
 exams, 72
 components of:
 artists, 74
 dates, 74–75
 locations, 74
 medium/materials, 75
 periods/movements, 75
 titles, 73–74
 short-answer, 78–80
 studying for, 75–78
Space, 49–52
Stangos, Nikos, 111
Stokstad, Marilyn, 43, 99
Style, 58–64

T

*Thames and Hudson Dictionary of Art
 and Artists* (Stangos), 111
Thesis statement, 121
Titles, on art history exams, 73–74
Tour, Georges de la, 56
*Trinity with the Virgin, Saint John the
 Evangelist, and Donors*
 (Masaccio), 42, *44,*
 51–52, 54
Triumphal arch, 11

U

Unknowns, on art history exams, 73,
94–96

V

Value, of color, 57
Vanishing point, 52
Vertical perspective, 52
Visual description, in art history
lectures, 18
Visual literacy:
defined, 2
value of, 1–3

Vital statistics:
in art history lectures, 12–16
chronology and, 12–16
location and, 16
for response essays, 37–38
Volume, 45

W

Water Lilies, Giverny (Monet), 7, 47, 57
Woman and Maid, 49–50, *50*
Woman from Willendorf, 42, *43,* 62, 95
Wright, Frank Lloyd, 16
Writing About Art (Sayre), 34, 117
Wyman, Marilyn, 117